MARK LINDQUIST

Revolutions in Wood

BY ROBERT HOBBS

Hand Workshop Art Center
Richmond, Virginia
University of Washington Press
Seattle and London

Acknowledgments

This publication was issued on the occasion of the exhibition *Mark Lindquist: Revolutions in Wood*, organized by the Hand Workshop Art Center, Richmond, Virginia. Exhibition schedule: Hand Workshop Art Center, Richmond, Virginia, September 15 - November 12, 1995; Renwick Gallery of the National Museum of American Art, Smithsonian Institution, Washington D.C., March 15 - July 7, 1996; Virginia Beach Center for the Arts, Virginia Beach, Virginia, July 28 - September 8, 1996; and Florida Gulf Coast Art Center, Belleair, Florida, April 25 - June 22, 1997.

This exhibition and publication have been made possible through the generous support of Arthur and Jane Mason, the Eric and Jeannette Lipman Foundation, and Cadmus Communications Corporation.

The Hand Workshop Art Center gratefully acknowledges additional project support from Paul Avis, Jay Barrows, Rejena and William Carreras, Jean Crutchfield, Robert Hobbs, Mrs. Edmund J. Kahn, Sydney and Frances Lewis, Arthur and Jane Mason, Robin Payne, Margaret A. Pennington, Gary and Ruth Sams, and Mr. and Mrs. Richard Winneg.

Cover
Ancient Inner Anagogical Vessel Emerging, 1994
cherry burl
12 x 18
collection of Arthur and Jane Mason

Project Director
Paula Owen

Curator
Robert Hobbs

Photographer
Paul Avis

Designer
Jean Crutchfield

Printer
Cadmus Communications Corporation

All dimensions are in inches; height precedes width.
Unless otherwise noted (except in the catalogue of the exhibition), works of art are in private collections or the artist's own collection.

ISBN 0-295-9706-7

Distributed by the University of Washington Press
P.O. Box 50096
Seattle, WA 98145

Director's Foreword

PAULA OWEN

In organizing the exhibition *Mark Lindquist: Revolutions in Wood,* the Hand Workshop Art Center reaffirms an essential function of the organization from its founding thirty-two years ago: to foster an appreciation of both tradition and innovation in the visual arts, especially the craft arts.

Begun in an historic home in inner-city Richmond in 1962 near the site of Patrick Henry's "Give me liberty or give me death" speech, the Hand Workshop soon evolved into a model for other craft organizations then emerging across the country. The "American craft renaissance" had spawned a need for support organizations that would foster appreciation of contemporary crafts. The Hand Workshop fulfilled this mission through instructional classes and a variety of other programs, many of them with community as well as creative goals. Changes in the visual arts over the years have prompted parallel changes in the organization, though the goals have remained remarkably similar.

Today the Hand Workshop Art Center is a community-based, non-profit enterprise for visual art education and exhibition. It is still located in inner-city Richmond, in a former dairy, but now has 21,000 square feet of space for classes, galleries, and studios. Each year more than 2,500 adults, children, and teenagers take art classes taught by professional artists at the center, and many artists use studio facilities for the creation of new work. Instructional programs in ceramics, weaving, printmaking, papermaking and the book arts, drawing, design, and metalsmithing are also offered to public-school students, at-risk children and teenagers, and the artistically gifted, augmenting those offered for the adult general public. In addition, six to ten exhibitions originated by the Center are presented annually. These group and solo exhibitions present the work of outstanding local, regional, national, and international artists working in a variety of styles and media.

Hand Workshop exhibitions usually spotlight artists working in interdisciplinary, collaborative, or crossover media, as well as prominent artists like Mark Lindquist whose remarkable work cannot be easily categorized but is unquestionably powerful on several levels. As in many other aspects of contemporary life, the language of art is becoming more and more ambiguous, so these exhibitions often challenge formal and theoretical preconceptions and question accepted definitions about words such as "traditional" or "contemporary."

It is a great honor to have collaborated with Mark Lindquist, one of the most renowned artists in the field, and Robert Hobbs, noted scholar who holds the Rhoda Thalhimer Endowed Chair of American Art, Virginia Commonwealth University. It is also congruent with the Workshop's philosophy, which has deliberately circumscribed seeming polarities in target audience, artistic viewpoint, and purpose for many years. The resulting liberty to examine new ideas and methods in art while maintaining a respect for tradition has also been the hallmark of both Mark Lindquist and Robert Hobbs. In their work they have demonstrated extraordinary commitment to crossing established boundaries to blaze

new trails in our thinking about and experiencing of art. It has been personally inspiring to work on this project with them. Their intelligence and generosity have infused it with meaning and purpose from the beginning.

Robert Hobbs and I thank Mark Lindquist for sharing his work and gratefully acknowledge the many individuals whose contributions and resources have helped to launch and sustain this project, including Marcia Thalhimer, who first suggested this exhibition; Kathleen Lindquist, who has helped enormously with proofing copy and researching biographical material; Roger Paph, Mark's able chief assistant; Paul Avis, photographer-extraordinaire; John De Mao, Chair of Communication Art and Design of Virginia Commonwealth University; Jerry Bates and Joe DiMiceli for generously sharing this department's equipment; Jean Crutchfield, who designed this handsome catalogue, and Robin Payne, who assisted as consultant; Michael Monroe, whose endorsement of the project helped give it life; those individuals who have agreed to lend exceptional pieces for the duration of the exhibition's tour; Sydney and Frances Lewis for their assistance in storing the work between venues; Arthur and Jane Mason for their financial and moral support; the Eric and Jeanette Lipman Foundation and Cadmus Communications Corporation for generous financial support; and the National Endowment for the Arts, the Virginia Commission for the Arts, and the Hand Workshop Art Center board of directors and staff for their myriad efforts to see that the exhibition and the organization flourished.

Mark Lindquist: Revolutions in Wood

ROBERT HOBBS

Mark Lindquist, c.1977

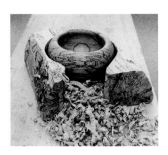

Mark Lindquist working on the lathe, late 1970s

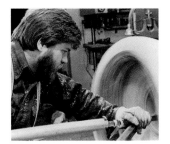

Bowl turned from spalted wood, c.1978

To a casual observer Mark Lindquist might at first appear to be an epigone of the American woodturning movement's first generation, which was led in the 1950s and 1960s by his father Melvin Lindquist who initiated the use of spalted wood, Rude Osolnik who rethought and reinvigorated Southern folk traditions of production woodturning, Bob Stocksdale who delighted in examining the inherent properties of various exotic materials, and Ed Moulthrop who originated ways to turn monumental vessels and envelop them in space-age plastics. However, Lindquist's contributions to this movement in terms of technical innovations and reconsideration of the vessel as a sculptural form rich in cultural and stylistic associations are so profound and far-reaching that they have reconstituted the field. Recalling his attitudes in the late 1960s when he began, this remarkable innovator has said, "I did not then care for the time-honored traditions of the craft, and I do not now care about the taboos of the purists."[1] His generosity in disseminating his ideas and techniques among great numbers of woodturners through carefully researched essays on his ground-breaking discoveries and his basic primer *Sculpting Wood: Contemporary Tools and Techniques*[2] has had the net result of making many of his pioneering feats regularly accepted practices. Some of his important technical innovations have received such a sweeping imprimatur from the modern studio woodturning movement that they need to be recalled in this study, together with their dates, in order to assess properly his lasting impact on this field. In addition, his artistic reconfiguration of woodturning in terms of Korean and Japanese ceramics, oriental philosophy, and Judeo-Christian symbols demands investigation in order to understand how he has transformed this genre into a metaphoric discourse on the nature of being.

His very first technical innovations in woodturning began at the end of the 1960s when he started to combine lessons learned from courses in modern art at New England College in Henniker, New Hampshire with an intense grounding in Zen Buddhism that he attained while working, during the years 1969-1971, as an assistant to the professor of pottery and Zen adherent Darr Collins. Having an early familiarity with woodturning since childhood, when he assisted his father, Mark was comfortable with the medium and accustomed to seeing its limits challenged. His father, who worked at General Electric as a lathe operator before becoming a master machinist and then a manager of quality control, found that the newly produced carbide-tipped tools that were originated and used by this corporation in the 1950s could be adopted for the uneven hardness of spalted wood. Because spalting, a New England term for the carbonaceous deposits in dead wood resulting from fungi working in combination with the right soil and climatic conditions, can produce incredibly beautifully marked wood, Mark was accustomed to regarding imperfections and even rotting wood as potential aesthetic materials capable of yielding significant results.

Robert Hobbs holds the Rhoda Thalhimer Endowed Chair of American Art, Virginia Commonwealth University.

This attitude of prizing flaws as forms of beauty was reinforced by his careful reading of Sōetsu Yanagi's *The Unknown Craftsman: A Japanese Insight into Beauty* and Okakura Kakuzo's *The Book of Tea* [3] as well as his study of the pottery of the twentieth-century Japanese master Kitaoji Rosanjin. In both texts the unselfconscious art of the tea bowl, which is epitomized by humble Korean vessels made for daily use, is discussed. A similar emphasis on simplicity, humility, and poverty has been important to Lindquist's art since this time and is evident in his *Early Spalted Bowl,* 1969-70 (page no. 25; collection of the artist), with a prominent hole, that memorializes in wood the traditional bell-shaped ceramic teabowl form. Put in the language of modernism, Lindquist was discovering a way to manifest his ideas in terms of his chosen material so that meaning is inherent in the spalted wood, the asymmetrical turning of the vessel, and even his decision to glue it together after it was accidentally broken, allowing it to become literally and metaphorically a collection of natural shards. His decision to allow a piece of bark to remain in his *Turned Spalted Bowl with Bark Inclusion,* 1970 (page no. 26; collection of the artist), was in part a response to the inside of a Rosanjin plate decorated with a serpent. At the time this liberality represented a high watermark acknowledged by Darr Collins who regarded it as Mark's first important work. While *Turned Spalted Bowl with Bark Inclusion* was a milestone in the woodturning movement, this piece was soon superseded by the aesthetic possibilities offered by the bark covering *Meditating Vessel,* 1972 (page no. 43; collection of the artist).

Even though imperfections have been a mainstay of twentieth-century studio pottery, they were at first only permitted an indirect presence in the spalted wood that Melvin Lindquist was employing as a natural patina for his pristine shapes. Among woodturners the dominant ideology until the mid-1970s had been a streamlined modernism consistent with the 1930s machine aesthetic of Gilbert Rhode and Donald Desky. Instead of working with nature, the practitioners of this craft were intent on harnessing and dominating it. Stocksdale, for example, states,

> The forms are developed on the lathe, for many times I have to change my initial
> design to eliminate flaws in the piece of wood.[4]

Mark Lindquist's innovations of circa 1969-1970, including the decision to investigate the aesthetics of such irregularities as cracks, bark inclusions, and asymmetrical turning, represented a radically new approach that was consistent with ecological thinking and the back-to-earth movement in the late 1960s and early 1970s. Lindquist was both a product of his time and a distillate for manifesting this new ideology in compelling aesthetic terms. His move was provoked by such passages in *The Unknown Craftsman* as

> Why should one reject the perfect in favour of the imperfect? The precise and
> perfect carries no overtones, admits of no freedom; the perfect is static and regulated,
> cold and hard. We in our own human imperfections are repelled by the perfect, since
> everything is apparent from the start and there is no suggestion of the infinite....
> Beauty in the Tea ceremony does not ultimately reside in imperfection....Rather, it
> should be seen in terms of musō, the Buddhist idea of unchanging formlessness
> behind all phenomena....True beauty in Tea cannot lie either in the perfect or the

imperfect, but must lie in a realm where such distinctions have ceased to exist, where the imperfect is identified with the perfect.[5]

Feeling free from the accepted rules of woodturning, Mark was able to create such an early transgressive piece as *Go Paul-Go*, 1971 (page no. 41; collection of the artist) which joins two hollow turned vessels and combines turning with boldly carved waves and a fluted border — a free-wheeling attitude that would later characterize many works turned and carved with a chain saw. An homage to Paul Gauguin's wood carvings, the vase represents Mark's early interest in aligning craft with art to forge a new highly metaphoric and sculptural genre that recalls its origins in ceramic containers.

In 1971 Mark was plagued by the war in Vietnam, susceptible to the draft, and increasingly alarmed that a graduate program in sculpture would academize him rather than provide opportunities to question present-day shibboleths of the art and craft worlds as had Darr Collins' Zen training. For these reasons he decided at mid-semester to relinquish the scholarship that had permitted him to enroll in Pratt Institute's MFA Sculpture Program. Although the then current jargon would have termed his decision "dropping out," this renouncement of formal education in favor of a personal investigation, which led briefly back to his father in Schenectady, New York and ultimately to the realization that woodturning was his metier, appears to have been not only a tough decision but also the right course for him to take. After a brief stay with his parents, Mark, his wife Kathy, and their son Ben moved back to Henniker where he had built a house and studio during his years as an undergraduate.

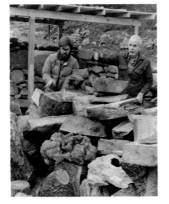

Mark and Mel Lindquist, C.1970

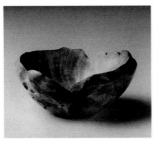

Natural Top Bowl, 1972,
maple burl, $2^1\!2$ x $5^3\!4$

During the next year he became involved in an intense and meaningful discourse with his father in which each learned from the other. While Melvin provided Mark with a consummate technique, Mark established a basis for rethinking the vessel in terms of oriental ceramics, ancient pottery, and contemporary sculpture. Soon Melvin was creating his own natural relics that assumed the form of Hopi baskets, Chinese ceramics, and Near Eastern pottery. Each development gave the other permission to go even further with his own investigations. From their independent researches in New York and in New Hampshire, as well as from the extended and often heated conversations that took place when they met at craft shows, each of them became imbued with a certainty about the direction the wood-turning movement should take.

This confidence enabled Mark to originate the natural top bowl which has become a mainstay for his work as well as for woodturning in general. An early example of this form, although not necessarily one of the most striking since the whereabouts of many of these early experiments is now unknown, is the turned maple burl titled simply *Natural Top Bowl*, 1972 (collection of the artist). A remarkable elaboration on this form with its carefully enhanced cracks is *The Great American Chestnut Burl Bowl*, 1975 (page no. 29; collection of Joan Alpert Rowen), made from an extremely rare piece of chestnut that had apparently been protected by being on the underside of a tree that had fallen over the raised banks of a stream. The tree most certainly had died as a result of the devastating chestnut blight of 1904.

For several years Mark had wanted to find a way to make a vessel with a rim as interesting as Collins' Japanese-inspired pots with their carved lips that often split, cracked, and warped during firing and sometimes even retained large blobs of ash which had fallen on them during this process. While working with burls on a bandsaw in order to optimize the grain of the wood, he noticed that the discards of burl and bark looked like the profiles of craggy landscapes. He found that he could achieve the effect he was after by relying on the natural surface of the burl and building a bowl around it. His approach can be connected with the oriental attitude of passivity or acceptance of the nature of reality that is particularly characteristic of Taoist philosophy and can be readily found in a number of books on Eastern philosophy, including Okakura Kakuzo's *The Book of Tea* which has already been cited as formative for Lindquist's thinking.[6] This concept of passivity can be explained psychologically as an ego-transcending state of awareness where Nature, not the self, becomes the active force, and the correctness of the inner workings of the universe is accepted: therefore imperfections can be judged as signs of a higher perfection or consciousness if one is willing to suspend the need to control and is willing to accept the world as given.

On occasion Mark will use humor in his bowls to emphasize his overall direction by undermining it. This strategy bears a remarkable similarity to the shock of humor often employed by Zen adherents. An example is the funky *Turned and Carved Sculptural Bowl with Carved Spoon,* 1975 (page no. 48; Greenville County Museum of Art, Museum Purchase with assistance from the National Endowment for the Arts), which parodies the artist's own natural top bowl by reinflecting its irregularity in the form of a carefully conceived and carved wavelet pattern. Seen in combination with its eccentrically shaped spoon, the vessel functions as a metawork commenting on the history and prosaic uses of treenware and reflecting as well on its own relatively new status as an art form on a par with the Japanese kimonos referred to as "kosode" that are regarded as a high form of art rather than considered mere clothing.

From this initial phase of carrying on conversations with Collins and his father, Lindquist moved to the position of establishing a dialogue with the overall modern studio woodturning movement by identifying its founding father James Prestini, publishing articles about both his own and his father's investigations that enabled others to incorporate these innovations in their work, and looking for ways that the traditional vessel form could be redefined in sculptural terms through carefully studying the contributions of Jean Arp, Constantin Brancusi, Henry Moore, and Isamu Noguchi.

He was among the first in the field to acknowledge the great significance of the architect/woodturner James Prestini, having been introduced in 1978 to Prestini's work by Penelope Hunter Stiebel, Curator of Twentieth Century Decorative Art for the Metropolitan Museum of Art in New York. In the introduction to his book *Sculpting Wood,* Lindquist writes,

> One important sculpting tool which has been overlooked for centuries is the woodwork-
> ing lathe. Arp used a lathe for a few pieces, as have several other sculptors. But only
> beginning with the work of James Prestini in the 1930s has the lathe gained prominence
> as a tool for sculpture.[7]

He discovered that Prestini had been featured in a 1949 exhibition at the Museum of Modern Art, New York, which extolled his Bauhaus leanings, particularly his emphases on simplicity and usefulness. In 1985, at Lindquist's prompting, his fellow woodturners publicly recognized Prestini's accomplishments at the first national woodturning conference held at the Arrowmont School of Arts and Crafts in Tennessee.

In addition to unraveling the history of this relatively recent movement, Lindquist shared the knowledge he and his father had amassed about spalted wood in a 1977 essay published in *Fine Woodworking* in which he documents and describes this phenomenon and suggests its aesthetic potential.[8] The following summer this periodical published his follow-up article entitled "Turning Spalted Wood"[9] in which he details ways to cope with the unpredictableness of this material and outlines the "equilibrial abrasion" that he and his father originated.

This essay includes the artist's philosophy about the vessel form and his suggestions about how it might represent a cosmological view of the universe:

> *I turn my bowls for appearance and artistic expression more than for utilitarian function. This may be a controversial approach among woodworkers, although it is in accord with artists and sculptors who accept a work for itself and not for its utility.... Its function is to display the beauty of nature and to reflect the harmony of man. It is wrong to ask the spalted bowl to function as a workhorse as well, to hold potato chips or salad or to store trivialities. The bowl is already full. It contains itself and the space between its walls.*

This emphasis on the fullness of the empty bowl correlates with the Eastern concept of the great nothingness that gives rise to being — the nonbeing and the uncreated synonymous with the godhead that precedes existence as we know it and creation as we customarily define it. One might consider Lindquist's vacant yet full bowls as symbols of the unmanifested versus the manifested and the unchanging versus the changing. Through an awareness of the cosmological and aesthetic potential of the negative space within and outside them, Lindquist's dynamically turned vessels augmented the Buddhist concept of "Samsara" or phenomenal cycle of birth and death, which is transitory, remains in constant flux, and lacks the essence of the unmanifested void. This understanding gives him the assurance that even humble bowls can be manifestations of a far greater world order.

Although the oriental view of the world continued to be crucial to Lindquist's work, he personally moved away from Zen Buddhism when he underwent a major reconversion to Christianity in 1972, attending first a fundamentalist Baptist church for five years before tempering his fervor and joining a Presbyterian congregation. He realized that he had been looking for a personal Christ figure in Buddhism and needed the assurance of divine grace that Christianity could offer him. Similar to many of his contemporaries who had become involved in drugs and who later converted to Christianity, causing the press to slight them as "Jesus freaks," Lindquist's spiritual quest grew out of a great personal need for renewal. He began to regard spalted wood as both a personal sign of "his rotten and decayed

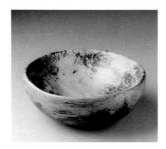

Lazarus Vessel, 1976, homemade
spalted wood, 3^14 x 8^34

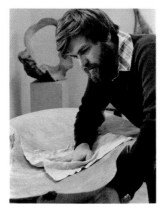

Mark Lindquist, late 1970s

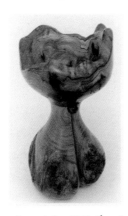

Brancusi Cup, 1976, 8^12 x 4
(Collection of the Metropolitan
Museum of Art)

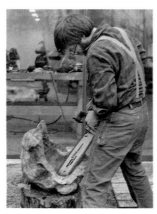

*Mark Lindquist carves interior
surfaces of a burl sculpture with a
chain saw,* c. 1979

humanity" and a symbol of being saved. Instead of merely practicing a craft, he was redeeming himself through his art. Wood became a means and a goal — a tree of life and a way of being reborn. This change in his spiritual outlook no doubt is the basis for his *Lazarus Vessel,* 1976 (collection of the artist), a turned blank of maple that was then buried for one and one-half years to prove the possibility of artificially induced spalting. Apropos his conversion and work, Lindquist has commented that "Christianity is the spirit that guides me, and Zen is the tool by which I create my art." Instead of merely replacing the formative role of oriental thought in his work, Christianity reinforces it. In 1979 Lindquist paid homage to his entire series of spalted bowls and to the phenomenal arising from the noumenal when he made *First-Fruit Bowl* (page no. 53; private collection) for a Swiss filmmaker who had come to the United States to film two spiritually motivated craftspeople.

In several of his most experimental works of the 1970s, Lindquist has found ways to join the noumenal and phenomenal so that they appear to be free sculptural adaptations of the interconnectedness and unity of surface making up a Mobius band. A notable example of this emphasis on joining outside with inside is *Sculptural Vessel,* 1979 (page no. 49; collection of Ronald and Anita Wornick). This work can be considered a union between the Eastern void giving rise to material reality and the Christian tree of life metaphor, which in this piece takes a cue from burls' frequent swollen appearance in nature that makes the trees producing them appear to be pregnant with new life. In addition, this sculpture relies on early twentieth century innovations in sculptural form that were originated by Jean Arp in his *Concretions* and Henry Moore in his secular recumbent madonnas cradling either their creative potential or lack thereof in the form of massive voids.[10] Arp had already played a role in several of Lindquist's turned and carved pieces, including the elm burl *Turned and Carved Covered Jar with Sculptural Handle,* 1976 (page no. 31; private collection), and the maple burl *Turned and Carved Footed Sculptural Vessel* of the following year (page no. 32; collection of Arthur and Jane Mason).

Less a dissertation on inner and outer space but still noteworthy for the way that the phenomenal becomes a platform for the noumenal is *Rolling Thunder,* 1979 (page no. 51; collection of Gary and Ruth Sams), which the artist views as a Japanese garden in embryo and which no doubt is intended as a critique of the gardens assuming the form of the sculpture and playgrounds that the Japanese-American Isamu Noguchi originated. This commingling of sculpture and its base had been prepared by Lindquist's intense study of the art of Brancusi, which he memorialized in the two-part piece constituting *Brancusi Cup,* 1976 (collection of The Metropolitan Museum of Art, New York).[11] *Rolling Thunder* is especially noteworthy from the point of view of technique because Lindquist not only harvested the sugar maple for this piece with a chain saw, but also, using a lightweight model to which he added a side handle, he was able to undertake its initial carving.

Well versed in early modernists' ongoing discussion about how machines can help or hinder humanity, Lindquist has been determined over the years to avail himself of technology so that his craft is far less an anachronistic extolling of the hand and more a

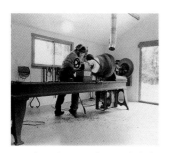

Mark Lindquist working at the lathe in his studio, late 1970s

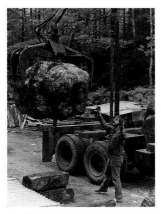

Mark Lindquist directs the placement of a gigantic New Hampshire yellow birch burl, early 1980s

study of ways the machine's small range of tolerance for precision can reinforce the human.

In 1976 he purchased a pattern maker's lathe from a salvage yard. Three years later he built an addition onto his studio so that he could begin, with Melvin's help, refurbishing and using this lathe in order to work on a much larger scale. He later reflected on the potentialities of the lathe as an artistic tool,

> *As new machines become more readily accessible, as the technology increases the possibilities for scale and control, sculptors may continue to turn to the lathe as an important process in their repertoire.*[12]

Rather than giving him, however, the sense that he was involved with high technology, this machine made Lindquist aware that he was employing an earlier generation of tools that related more to the past than to the future. He based his approach on Darr Collins' method of improvising a kiln from local materials and firing pots with recycled dirty crankcase oil mixed with diesel fuel and slab wood in order to set the stage for new types of accidents that would be more difficult, if not impossible, to attain with the best new equipment available. Applying Collins' epistemology, Lindquist employed primitive machines and pushed them beyond their normal tolerance for precision so that they functioned as equivalents to the percussion instruments that he played with the high school band and concurrently with two independent groups: one that featured old favorites of the big band era, and the other that favored the rock music of the recent British invasion. Soon after the large lathe was put in working order, Lindquist developed a way to use a chain saw as a "dumb" robotic implement so that he was able to operate it in lieu of the traditional gouges, parting tools, and chisels customarily employed for shaping and texturing turned wood objects. In order to accomplish this feat he had to slow the speed of the lathe so that it would be compatible with the chain saw. Unlike his early discoveries that he readily placed in the public domain, Lindquist has been more reticent about publishing his later techniques. It is to his credit that no other woodturner has found a way to use the chain saw in tandem with the lathe.

Even before using the chain saw for shaping and texturing vessels, Lindquist anticipated the aesthetics of his "primitive robotics" in *Amiran Krater*, 1980 (page no. 54; collection of Robert A. Roth). The piece was named for Ruth Amiran who had written *Ancient Pottery of the Holy Land* that provided him with Near Eastern, and consequently pre-Christian equivalents for the ancient Japanese Jōmon pottery he had come to respect. Fascinated with the matte textures of ancient ceramics as well as the number of pieces in this book that have been reconstituted from shards, Lindquist decided to employ chisels to do all the wrong things to the surface of this vessel, including ripping, tearing, and scarring its surface. Imbued with the example of Jackson Pollock's drip paintings, he looked for ways to transgress established rules and make the surface of his vessel as expressive as possible.

This dramatic change was an outcome of the intense debates that Lindquist was having with the New York sculptor Will Horwitt, whom he met in 1978 at the Rhinebeck Craft Fair when the two immediately began arguing if craft was art and woodturning could be a viable sculptural medium. Their ongoing disagreements resulted in a close friendship

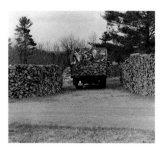

MacDowell Wood Piles, 1980

MacDowell Wood Piles, 1980

that provided Lindquist with easy access to the New York art world and to exhibitions of recent work in Soho such as the highly acclaimed *Bad Painting* show at the New Museum (1978) which broke taboos between fine and vernacular arts and transgressed current shibboleths about immaculate surfaces. Horwitt encouraged Lindquist to avail himself of the experience of the MacDowell Colony. And in 1980 Lindquist took his advice by spending March and April there. The initial impact of this brief yet important period devoted to pure research and enriched by conversations with artists, writers, and musicians in residence at the Colony was the creation of the *MacDowell Wood Piles,* an environmental piece of 40 cords of fire wood consisting of castle-like walls and gates of stacked wood, which also reiterated the profile of a mountain in the background. This impromptu environment, which was occasioned by the delivery of wood at MacDowell and was realized through the enthusiastic participation of other residents at the Colony, made Lindquist aware of the expressive power of large scale and rough textures. This piece can be considered formative to the increased size and rugged surfaces that separate his later successes from his earlier ones.

While *Amiran Krater* was one of the initial outcomes of the MacDowell experience, Lindquist returned home with the gift of a huge piece of spalted elm that he had discovered in the barn at MacDowell. The wood had been harvested approximately forty years earlier for a sculptor working at the Colony but had never been used. Lindquist had initially employed the piece in an indoor installation at MacDowell which captured some of the improvisational character of the *Woodpiles*. The following year he used this gift for the first major work lathe-turned entirely with a chain saw. A comparison of this vessel with his early *Fluted Bowl,* 1971 (page no. 27; collection of the artist), reveals a number of parallels, including simplicity of form and reliance on uncomplicated and repetitive surface decoration. In *The MacDowell Bowl,* 1981 (page no. 35; collection of Dr. and Mrs. Alan R. Lubarr), Lindquist has found a way to translate hand-carved fluting into a machined rhythmic pattern that depends on vibrations of the chain saw working in tandem with an industrial-sized lathe.

The rewards of *The MacDowell Bowl* were sustained in a series of magisterial vessels dating from the early 1980s that represent one of the major achievements of Lindquist's art. In his quest to deny the limits of the bowl, this artist redefined them in terms of the following essentials: 1) The interior is a concave surface. 2) The exterior is a convex surface. 3) The rim or mouth of the bowl speaks forcibly to the viewer. 4) The foot or base of the bowl sets the basic attitude for any vessel. In *Spalted Elm Burl Natural Top Bowl,* 1981 (page no. 56; Arrowmont School of Arts and Crafts Permanent Collection), these elements reinforce each other. They also accrue power through the eloquent, expressive patterns of spalted burl that provide a strong contrast with its traditionally polished body and reinforce the extravagant thickness of the bowl's natural top — a symbol of fullness, according to the artist.

In his imposing *Ascending Bowl #5,* 1981 (page no. 55; collection of Mr. and Mrs. Richard Winneg, Bedford, NH), with its rhythmically gouged and abraded surface marked by exposed tool marks, Lindquist also emphasizes the great scar-like vertical crack that provides

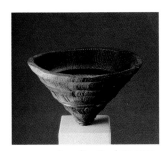

Ascending Bowl #7, 1987,
walnut, 13 x 20^3⁄$_4$
Collection of Arthur and Jane Mason

passage between inner and outer realms. In this piece the artist believes that he has created a metaphor of humanity coming in contact with its inner self. The title is intended as a response to Marcel Duchamp's *Nude Descending a Staircase, No. 2* (1912) which Lindquist regards as both a negative and decadent work. Another work in this series, *Ascending Bowl #7,* 1987 (collection of Arthur and Jane Mason) is screwed into a sculptural base to underscore its artistic nature. The piece is an ironic comment on Brancusi's art that joins sculptures with their pedestals.

The word "Nehushtan" that was used by Moses when he struck the Golden Calf in order to repudiate the Israelites for worshiping a mere idol is the title of an impressive vessel, 1982 (page no. 58; collection of Robert A. Roth), through which Lindquist contemplates the mesmerizing power of sculpture and suggests its role to be a vector for forces far greater than itself. To create this piece, he turned a natural top bowl upside down and transformed it into a powerful cylinder that reinforces its status as a catalyst of a transcendent experience rather than the event itself.

Since his father was finding ways to make turned wooden equivalents of Sung dynasty ceramics, Lindquist initiated a series of Unsung vessels that he intended as puns deflecting the power of these great Chinese vessels and serving as a way to honor unsung heroes, including the ancient Japanese Jōmon pots he has admired since his apprenticeship with Collins. A prominent example is *Unsung Bowl Ascending #1,* 1982 (page no. 59; collection of Mrs. Edmund J. Kahn), which attains the height of the Ascending bowls. This piece can be connected with Jōmon pottery in terms of its plasticity and castellated rim with bark inclusions, giving it the impression of a dramatic mountainous landscape.

The overall power of these magnificent bowls is sustained in *Chieftain's Bowl,* 1985 (page no. 63; lent by the Fuller Museum of Art), an homage to the artist's childhood experience as an Indian Guide and an expression of his great respect for Native Americans and their culture. The sides of this particularly rugged spalted maple burl are decorated with random cuts resembling leaves and vertical notches that the artist equates with feathers.

At the same time that he is enjoying the power attainable through a judicious increase in scale, liberal expansion of the natural top, and reliance on overall jagged textures, this artist embarks on a different type of work that focuses on the tensions that can attend creation. A number of these pieces look as if they have been caught at the beginning of the creative process or perhaps are conflations of entirely different stages of fabrication. The *Full Bowl,* 1981 (page no. 33; collection of Rhea S. Schwartz and Paul Martin Wolff), for example, has not been turned out: it still contains its central core section. According to the artist, this piece may indirectly result from the Metropolitan Museum of Art's acquisition of his *Brancusi Cup* that made him resolve not to repeat himself. This sale may also have encouraged him to consider his work sculpture and to devise a way to make his bowls equivalent to the Bad Paintings exhibited at the New Museum. Created about the same time that the artist was also introduced to Mark Tansey's paintings, whose subject is art's discourse, the *Full Bowl,* with its prominent, funky base, could be considered a metasculpture. It reflects on the

ludicrousness of current artistic criteria that permit painting and sculpture to be unfinished comments on process while demanding that craft remain tied to anachronistic standards of high finish.

With a similar tongue-in-cheek humor that has affinities with Zen logic and humor, Lindquist created *Evolutionary Bowl (Proto-Captive)*, 1982 (page no. 57; collection of Mr. and Mrs. Richard Winneg, Bedford, NH). The work can be considered the woodturning equivalent to Michelangelo's series of captives, consisting of struggling and bound figures, which have been regarded as incomplete because they are only partially released from their blocks of marble. Believing that Michelangelo intended to leave the block of marble partially intact because the pieces would be more powerful if their struggles are conceived as psychological and physical, as well as oriented to the medium constituting them, Lindquist decided that the process of making *Evolutionary Bowl* was as important as any resultant vessel. His title may be a sardonic comment on the survival of the fittest, which is often mistakenly attributed to Darwin, since it presents a struggle between the bowl and the tree from which it is made and thus pits commercial and artistic interests against nature.

His aims are reinforced in *Prisoner #3*, 1986 (page no. 64; collection of John and Robyn Horn), which refers to the choices and potentialities that lie in a piece of wood. The sculpture consists of the bowl and its constituent material, the slab of buckeye burl from which it is turned; and the two in turn point to the tree and ultimately to the creative force of nature itself. Since this buckeye burl resembles freshly quarried stone, it may refer to Michelangelo and his series of captives discussed above. The circle within this piece of buckeye could also be regarded as a metaphor for the oriental vision of ultimate reality, since its overall structure parallels the created phenomenal world in the form of the bowl, with its prominent and yet beautiful imperfections, that arise from the greater uncreated realm of absolute undifferentiated reality that is symbolized by the slab of buckeye. The artist considers the angular orientation of this sculpture reflective of the convention of Japanese woodblock prints whereby highly oblique angles signify great drama.

The explicit and implicit references to Michelangelo's sculptures in *Evolutionary Bowl (Proto-Captive)* and *Prisoner #3* become even more pronounced in *Ascending Captive #1*, 1992 (page no. 70; collection of John and Cheryl Ferguson), which provides a view of an ascending bowl imprisoned by its context, which ironically and perhaps even tragically is the medium constituting it. For this work Lindquist took a special maple burl that he had allowed to age in his barn for fifteen years. Although the work takes a retrospective view of earlier series, it augments them by presenting the interior of a bowl with its prominent plunge cuts created by a chain saw as an inversion of the way a burl grows on a tree so that, instead of being a protrusion, it becomes a giant navel providing a glimpse of the wood's inner nature. The human/nature conjunction in this anthropomorphosized fragment of a ravaged and old piece of wood is reinforced by the elaborate series of lines on the reverse that refer to forms of communication throughout human history, including references to ancient Mayan, Aztec, and Incan characters, Egyptian hieroglyphs, the Nazca lines in Peru, as well as

the pathways of integrated circuits in electronics. In this way *Ascending Captive* resonates between ancient and modern worlds.

These sculptures which play with tensions between artistic conceptions and the character of Lindquist's chosen media are contemporaneous with several highly mannered pieces that at first glance appear to be only occasions for the artist to exhibit his skill. An example, *Obviated Bowl*, 1984 (page no. 37; private collection), begins as a plain turned vessel before giving rise to a natural top bowl that in turn surrounds a hollow turned container. While this work is a technical feat, it also serves as an opportunity for Lindquist to take a retrospective view of the route he has provided the wood-turning movement. It can also be considered a symbolic statement about some metamorphoses the tree of life can symbolize. The artist has suggested that this work and his *Ancient Inner Anagogical Vessel Emerging*, 1994 (page no. 71; collection of Arthur and Jane Mason), which explores similar themes of transformation and metamorphosis, may both reflect his fascination with the description of the great Korean Kizaemon teabowl that Yanagi was privileged to see in 1931:

> I had expected to see that "essence of Tea," the seeing eye of Tea masters, and to test my own perception; for it is the embodiment in miniature of beauty, of the love of beauty, of the philosophy of beauty, and of the relationship of beauty and life. It was within box after box, five deep, buried in wool and wrapped in purple silk.[13]

Lindquist has conjectured that the ceremonial uncovering of the highly esteemed teabowl may be of far greater consequence to many people than the object itself. His assessment correlates with Yanagi's conclusion,

> When I saw it, my heart fell. A good Tea-bowl, yes, but how ordinary! So simple, no more ordinary thing could be imagined. There is not a trace of ornament, not a trace of calculation. It is just a Korean food bowl, a bowl, moreover, that a poor man would use every day — commonest crockery.[14]

While Lindquist does not attempt to create a teabowl in either of these elaborate pieces, he does structure a progression analogous to opening the boxes framing the Kizaemon vessel. In addition, both *Obviated Bowl* and *Ancient Inner Anagogical Vessel Emerging* create receptacles for enunciating space — a sine qua non for sculpture — and the void giving rise to form in oriental thought. Both titles provide telling clues for approaching them. In the former work, "obviated" suggests that the three bowls in one are impossible to use, hence unnecessary as prosaic objects and mainly of value as metaphorical structures. In the latter piece, "anagogical" from the Greek word "to spiritualize," proposes that the wood can transcend its material state when it opens itself to an inner realm.

Although most of Lindquist's work has focused on the limits and strengths of the vessel form, which has also been the mainstay of the woodturning movement, this artist has also made a number of forays in the direction of pure sculpture. One of his major pieces, *Silent Witness #1, Oppenheimer*, 1983 (page no. 61; collection of Margaret A. Pennington, Osprey, Florida), takes as its subject the tragic mien of Robert Oppenheimer, the brilliant

physicist who oversaw the creation of the atomic bomb and is reported to have said, "I have become death." Lindquist has connected him with the pillar of salt that Lot's wife became when she looked back. For this piece, he built a segmented column based on Egyptian prototypes. At the time, he was thinking of Greek caryatids, the axis mundi (the mythic column marking the center of the world), as well as New England boundary markers of stacked rocks on posts. In *Silent Witness #1* he conflates the tree of life with the tree of death by employing the same abstract shapes to connote either the positive experience of self-realization through Zen meditation or the horror of a nuclear holocaust. Using various fruit or nut woods for his segmented column that begins with a base of walnut before moving to either a bell or a torpedo shape of elm, Lindquist builds on his ironic theme with a meditation pillow of pecan that could also be read as a mushroom cloud before culminating the piece with an ascending vessel in walnut homologous with an abstracted flame. Choosing to make the bell or torpedo configuration in elm, a tree decimated in the Northeast by a widespread blight, enables the artist to invoke both the pathetic fallacy and the modernist practice of literalizing meaning in terms of a specific medium.

The following year while playing with various turned elements by stacking them in different configurations, Lindquist arrived at the combination of shapes that resulted in *Toreador*, 1984 (page no. 62 ; provided by Ethan Allen Inc., Danbury, Connecticut). At first, when the largest turned element with its prominent crack was placed on a small base, the ensemble suggested to the artist either a barrel-chested figure or a Japanese storage jar. Because the piece seemed most to resemble another figure, Lindquist topped it with a large fluted vessel notable for its expressive breaks and imposing crack. The effect became both a defiant and an apologetic figure that the artist pronounced a self-portrait of himself in the guise of a bullfighter. In conversation with this writer, Lindquist has admitted that most of his pieces can be considered symbolic self-portraits, including even *Silent Witness #1* with its references to Oppenheimer, because it deals with his own dilemma about unleashing the supposed benefits of technology on an unsuspecting world. Perhaps a more accurate assessment of this and other pieces' relationship to this artist is that they represent meditations on those identities with which he has special empathy.

Lindquist considers *Toreador* to be a totem on a par with those constructed by Northwest American Indian tribes that signify a group's identity. As such, it reinforces his position within his culture by showing how he can use turning to embrace the world. Because turned forms are naturally symmetrical, they connote the idea of harmonious and balanced centers expressive of a dynamic process. Generally they are strong and self-reliant with anthropomorphic implications. In *Black Eagle,* 1986 (page no. 38; collection of Howard and Jane Cohen), a personal totem referring to the Indian Guide name assumed by Melvin — Mark's was White Eagle — the artist acknowledges his father's importance at the same time that he formally takes leave of more traditional woodturning in favor of sculpture. Although he continues to use turned elements in his art, he no longer regards the vessel as his only area of exploration. This formative experience of being an Indian Guide serves as a basis for

Small Totemic Sculpture, 1987 (page no. 39; collection of Arthur and Jane Mason), that the artist considers to be an abstract quiver with feathers. Although *Chieftain's Bowl #3,* 1987 (page no. 65; collection of Arthur and Jane Mason), might have seemed more a break-through than a logical next step, this piece with its assertive gnarled maple burl resting on a short plinth of walnut extends the theme of Native Americans' strength and the artist's long-term admiration for their way of revering nature.

The almost pugnacious character of this piece might be related to an event in the artist's life two years before it was made. In the winter of 1985, Lindquist survived a horrendous accident that occurred when his assistant fell asleep while driving 65 miles per hour outside Macon, Georgia, and went off the highway, going down an embankment at a weigh station. The van flipped and rolled over five to seven times. Fortunately, the assistant was not seriously injured, and Lindquist, who had been pinned inside the truck with gas dripping inside, survived with a broken elbow, several bruises, and a concussion. The accident provided him the opportunity to take stock of his life and career and to chart carefully his next steps.

In 1988 he made the decision to return to school in order to earn the Master of Fine Arts degree that he had decided not to pursue in 1971. Since he lived in Quincy, Florida, he elected the studio program at Florida State University in nearby Tallahassee. The ostensible reason for this career choice was the desire to have the required qualifications to teach if he should later wish to move in that direction. Coupled with the pragmatics of this approach was a desire to spend several years thinking about how woodturning might become the basis for a new type of sculpture. This sustained investigation of woodturning as a sculptural mode resulted in the Ichiboku series that was inspired by information encountered in courses with the late Dr. Penelope Mason, a noted specialist in Japanese art. For this series of lathe-turned sculptures, Mark chose the term "Ichiboku," meaning "one tree," because it refers to a type of Japanese ninth-century sculpture made from single blocks of wood.

In the first piece in the series entitled *Natabori,* 1989 (page no. 68; private collection), Lindquist invokes the two traditions of carpentry and sculpture that came to the forefront in Japanese Buddhist sculpture, which aimed to reinvigorate art by relying on the essential properties of the material in which it is conceived. The Japanese word "Natabori" combines the idea of a rough cut surface with a blocky unfinished figure. This piece is con-ceived in a huge trunk of cherry wood that the sculptor chose because of its natural torsion. The twisting of the trunk gives the piece a dynamic thrust, which he has enhanced by subtly enlarging the waving lines formed by natural cracks in the wood and by polychroming the piece with a mixture of stains and paint. Lindquist intends this piece to follow the Buddhist ideal of returning sculpture to a naive form out of respect for its material. Similar to some ancient pieces of Buddhist sculpture, his *Natabori* oscillates between resembling a tree about to become a sculpture and a weathered sculpture returning to its natural state. The piece is an equivalent in wood to the extremely weathered Parthenon marbles at the British Museum that look as if they are returning to their original, natural state. *Natabori* is concerned with transition and change, with a return to origins, and with essences. It takes the craftsman's fascination with

materials to the level of art since materials become, first and foremost, metaphors of being.

Because each of the sculptures in this series takes on a distinct personality, special names with particular associations have been chosen. *Akikonomu*, 1989 (page no. 69; collection of Arthur and Jane Mason), which is richly decorated in bright, almost impressionist colors and is far more ebullient than most works in the series, means "lover of autumn." This title is the name of the daughter of one of Prince Genji's early loves in the eleventh-century novel *The Tales of Genji*. Akikonomu married the emperor Reizei who arranged for special gardens to be planted outside her veranda. These plantings were particularly beautiful during her favorite season, autumn. The deeply saturnine *Mongaku*, 1989 (page no. 67; collection of the artist), who is acknowledged in Lindquist's sculpture with its large crack permitting deep shadows and an inwardly oriented presence, is named for the late twelfth-century samurai who determined as his penance to stand under an ice-cold waterfall. Since he later resided deep within the mountains outside Kyoto, his reincarnation as this darkly meditative sculpture made from a tree trunk seems appropriate.

In the past twenty-six years since he first began to rethink the major assumptions of the modern studio woodturning movement, Mark Lindquist has made so many adventurous departures that the overall configuration of turned vessels has been dramatically changed. Among his contributions are popularizing the spalted wood his father discovered; artificially inducing spalting; developing the natural top bowl; mining the aesthetics of bark inclusions and other so-called imperfections; redefining the turned vessel in sculptural terms; breaking with accepted rules about highly polished finishes in favor of the expressivity of ragged and tooled surfaces; rethinking the craft of woodturning in terms of robotics; making extensive use of the chain saw; and creating large lathe-turned sculptures. During this period he has increasingly closed the gap between artistry and art, and at the same time he has transformed woodturning from handcraft to an art form dependent on the percussion of primitive machines forced beyond their expected tolerance so that they become highly expressive devices. Although his work has been highly lauded, often emulated, and eagerly collected, many of Lindquist's revolutions in wood have been so successful that they have been accepted as truisms of the field and have merged into the standard practices of the modern woodturning movement. The examination of Lindquist's contributions occasioned by this retrospective exhibition will hopefully encourage woodturners, collectors, and historians of the genre not only to reflect on his many advances that have helped to make this area so fecund and exciting in the past twenty-six years but also to consider the real aesthetic merits of his output.

Footnotes

1. Edward Jacobson, *The Art of Turned-Wood Bowls* (New York: E. P. Dutton, Inc., 1985), p. 42.

2. Mark Lindquist, *Sculpting Wood: Contemporary Tools and Techniques* (Worcester, Massachusetts: Davis Publications, Inc., 1986). In the introduction, Lindquist writes, "This book is for all students of woodworking and wood sculpture, whether they come from a technical or artistic background. It covers the nature of wood, the making and maintenance of tools, the development of new technologies, aesthetic principles, historic influences and philosophical inquiry — all essential elements of wood sculpture."

3. Sōetsu Yanagi, *The Unknown Craftsman: A Japanese Insight into Beauty* (New York: Kodansha International Ltd., 1972). Okakura Kakuzo, *The Book of Tea* (Rutland, Vermont: Charles E. Tuttle Company, 1956). Personal information regarding Mark Lindquist and his work has come from a series of extensive interviews conducted by Robert Hobbs in June 1989, May 1991, May 1992, and January 1994.

4. Jacobson, p. 74.

5. Yanagi, pp. 120ff.

6. The writings of A. K. Coomaraswamy have been particularly important for Mark Lindquist, specifically, *The Transformation of Nature in Art* (New York: Dover Publications, 1934). Since Coomaraswamy believed that the Hindu, Buddhist and Taoist systems of belief share certain basic assumptions about the nature of reality that allows them to be grouped together, I will do so in my discussion of Lindquist's art and its possible connections with oriental thinking.

7. Lindquist, p. ix.

8. Lindquist, "Spalted Wood," *Fine Woodworking* (Summer 1977, Vol. 2, Number 1), pp. 50-53.

9. Lindquist, "Turning Spalted Wood," *Fine Woodworking* (Summer 1978, Number 11), pp. 54-59.

10. My reading is based on Moore's early studies of the Madonna and Christ Child that gave rise to the series of women holding the void within them. I would propose that Moore's figures develop from the Nietzchean claim that the wide-spread ability to visualize an active godlike force has been lost in the modern world.

11. *Brancusi Cup*, $8^1/_2$ inches high, is made of spalted elm burl and cherry burl, with a soapstone inset.

12. Lindquist, p. ix.

13. Yanagi, p. 191.

14. Ibid.

Early Spalted Bowl, 1969-70, spalted maple, $3^1{}_2$ x $5^1{}_2$

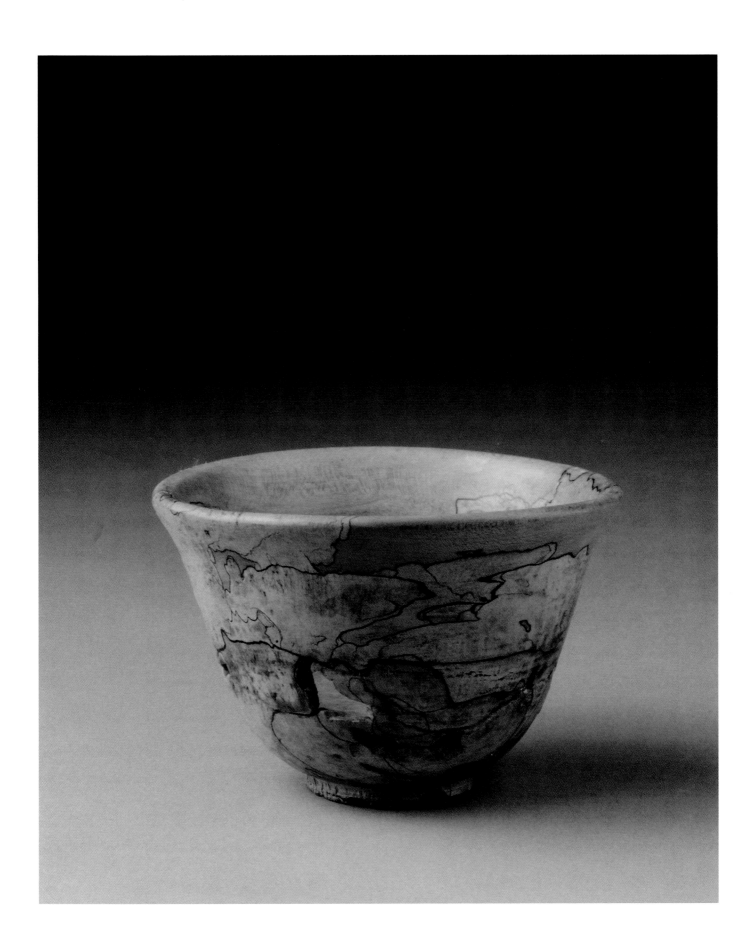

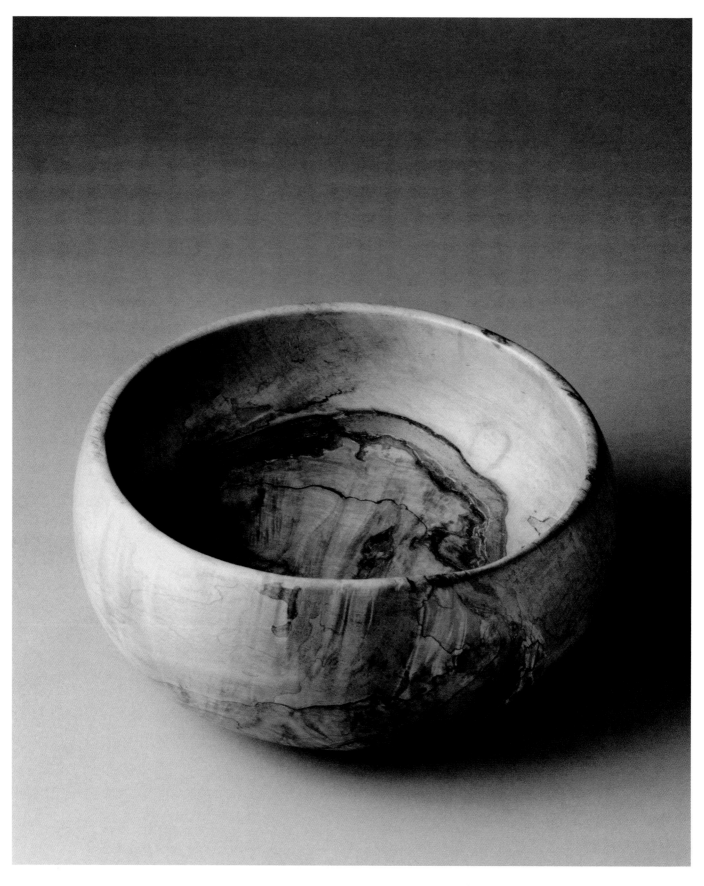

Turned Spalted Bowl with Bark Inclusion, 1970, spalted maple burl, 5 x 11

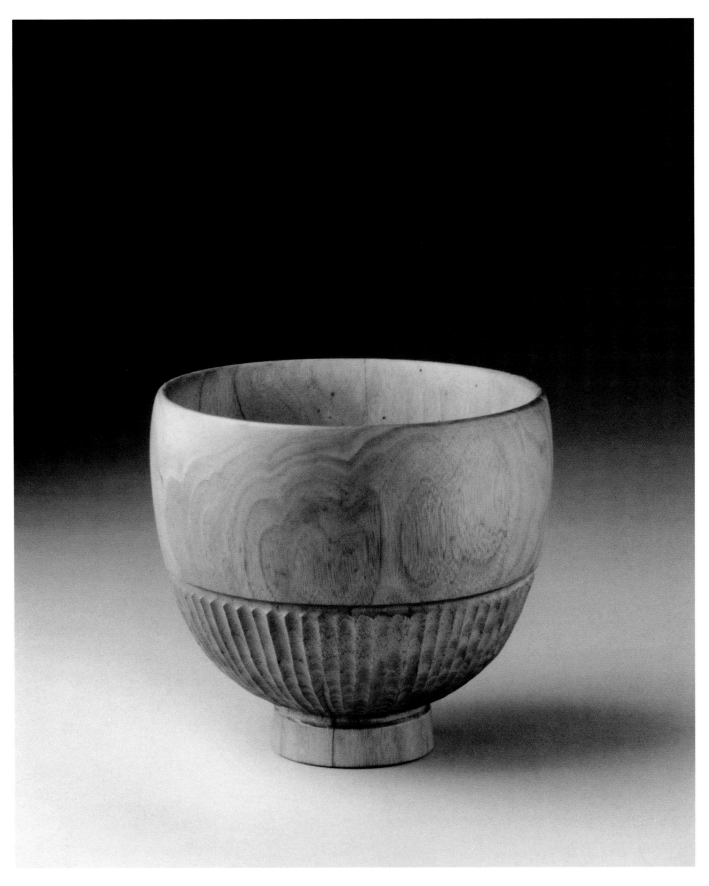

Fluted Bowl, 1971, turned and carved, butternut, $5^{1}2$ x 6

The Great American Chestnut Burl Bowl, 1975, chestnut burl, 5 x 14, collection of Joan Alpert Rowen

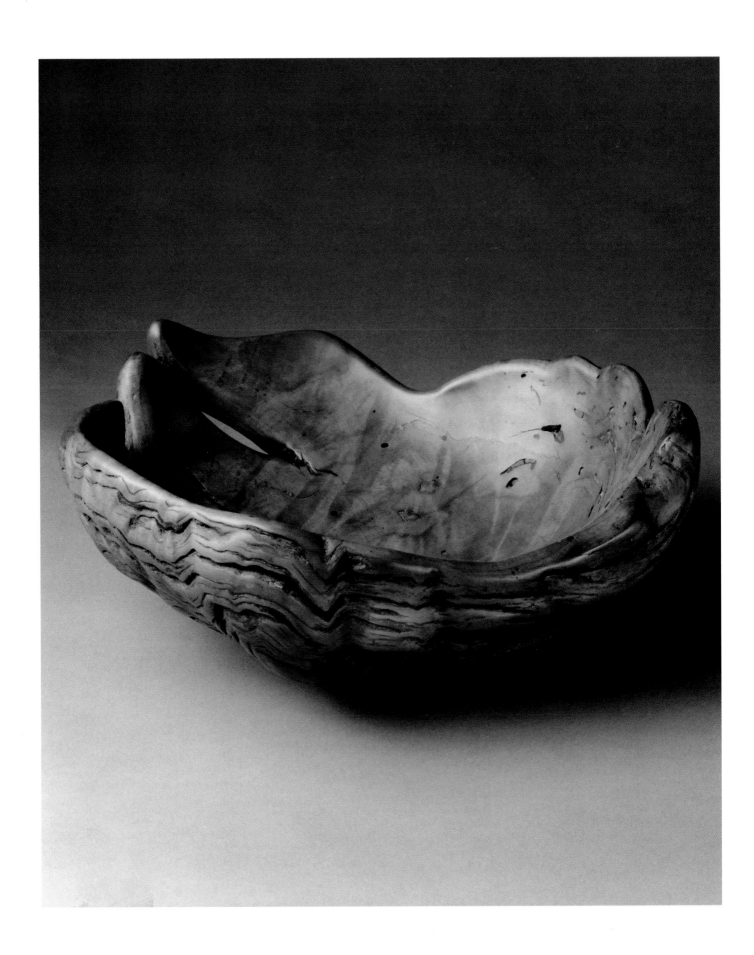

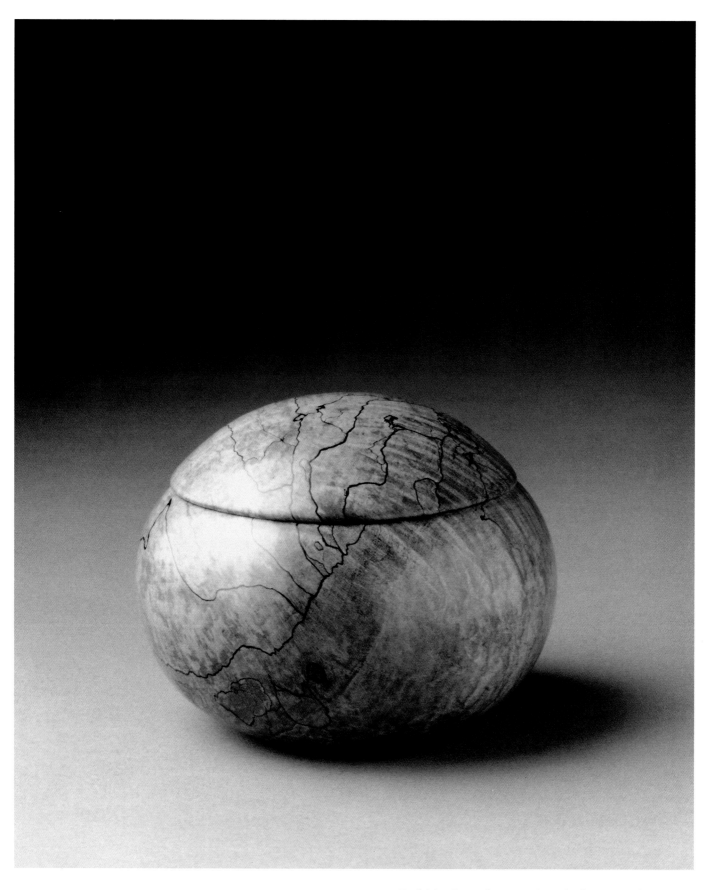

Lock Top Covered Jar, 1976, spalted tiger maple, $3^{1}2$ x 4

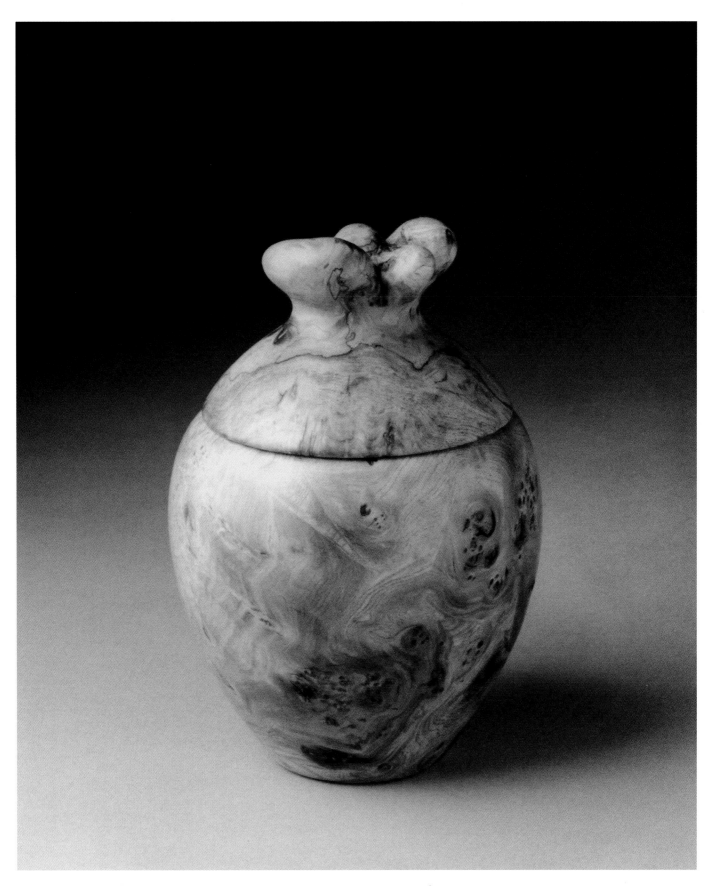

Turned and Carved Covered Jar with Sculptural Handle, 1976, elm burl, 8 x 5^12

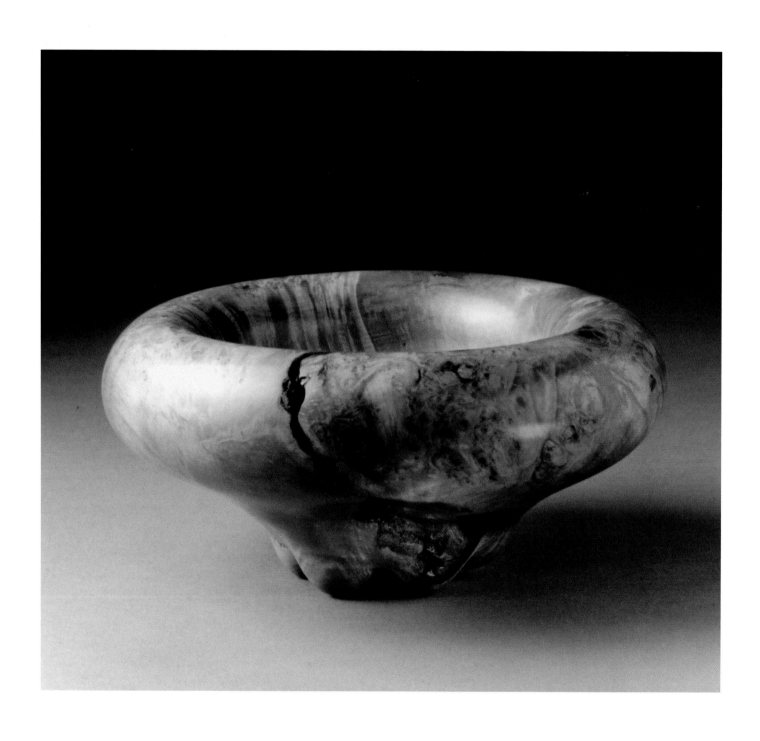

Turned and Carved Footed Sculptural Vessel, 1977, maple burl, 5 x 10, collection of Arthur and Jane Mason

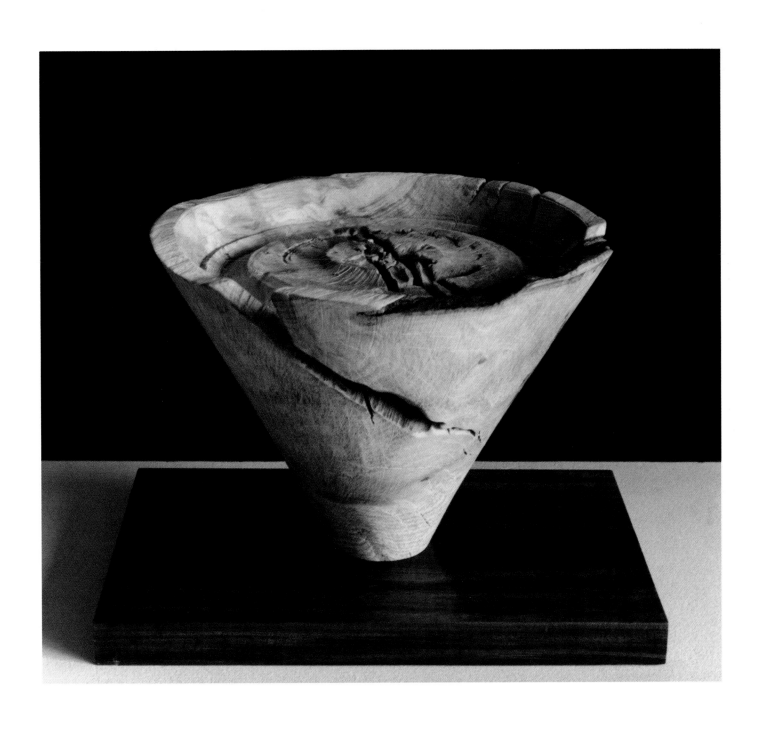

The Full Bowl, 1981, beech burl, padauk, 12 x 12, collection of Rhea S. Schwartz and Paul Martin Wolff

The MacDowell Bowl, 1981, spalted elm, 23 x 33, collection of Dr. and Mrs. Alan R. Lubarr

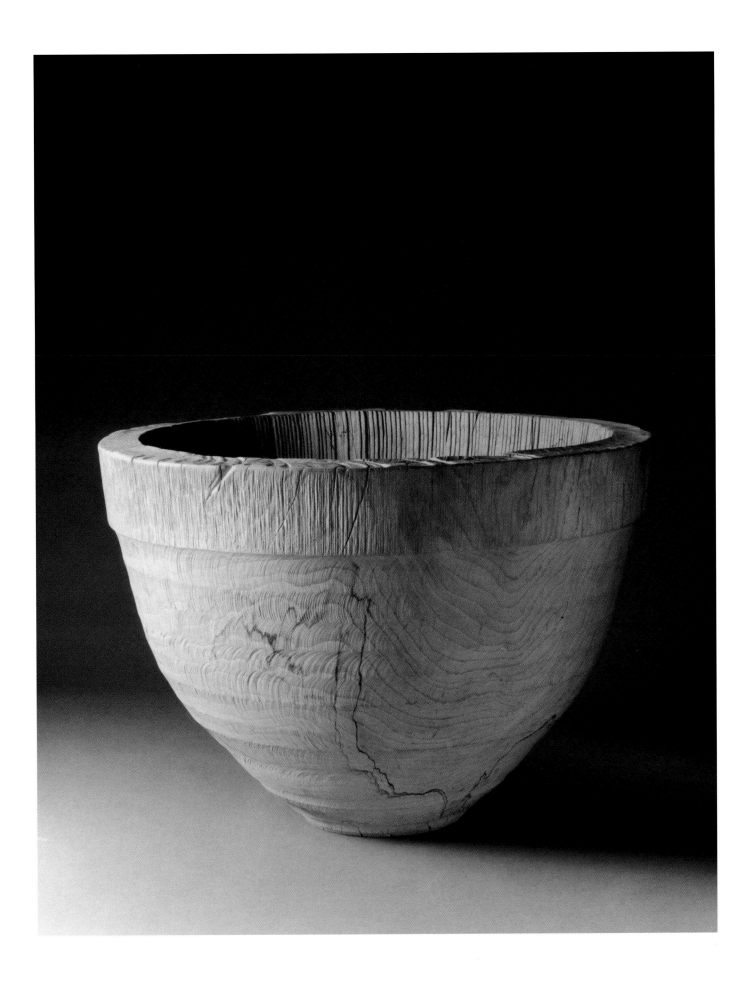

Obviated Bowl, 1984, elm burl, 12 x 12

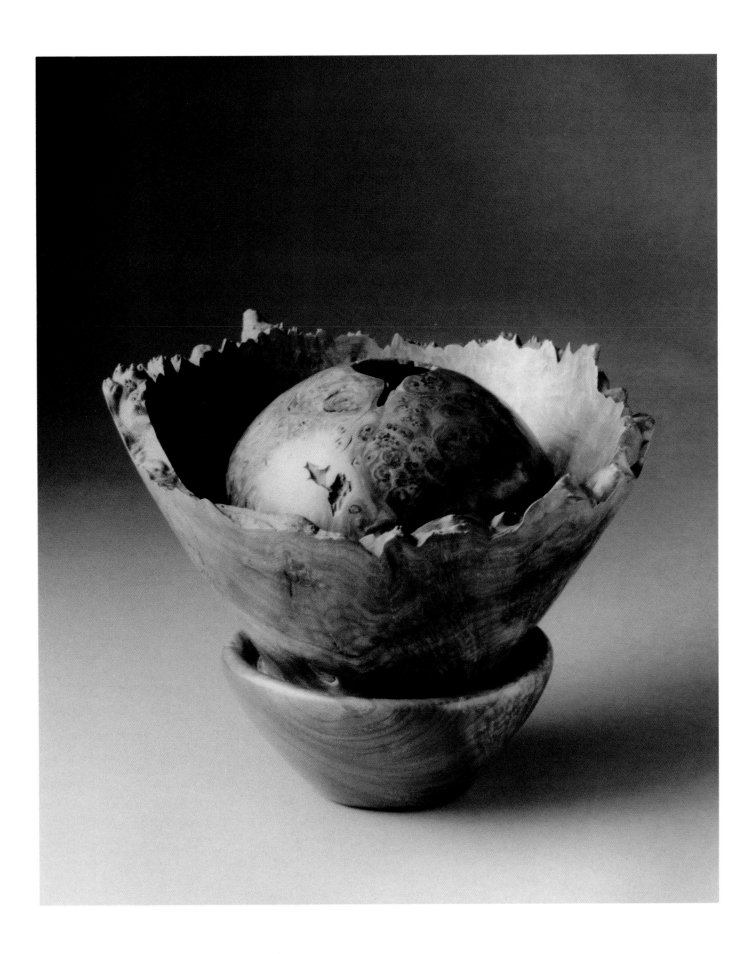

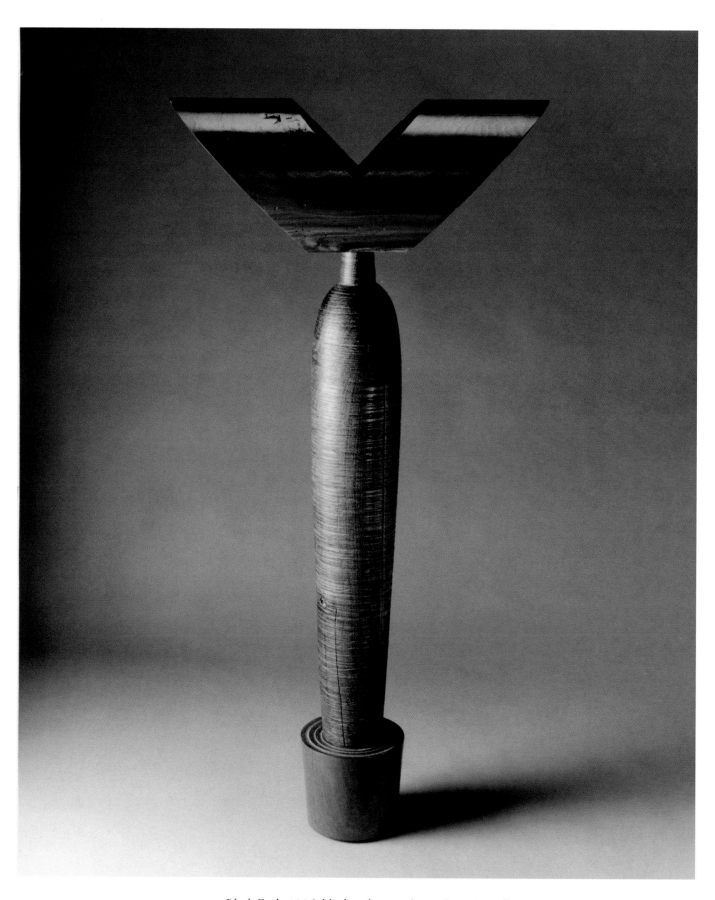

Black Eagle, 1986, black walnut, $52^1{}_2$ x 16 x $10^1{}_2$, collection of Howard and Jane Cohen

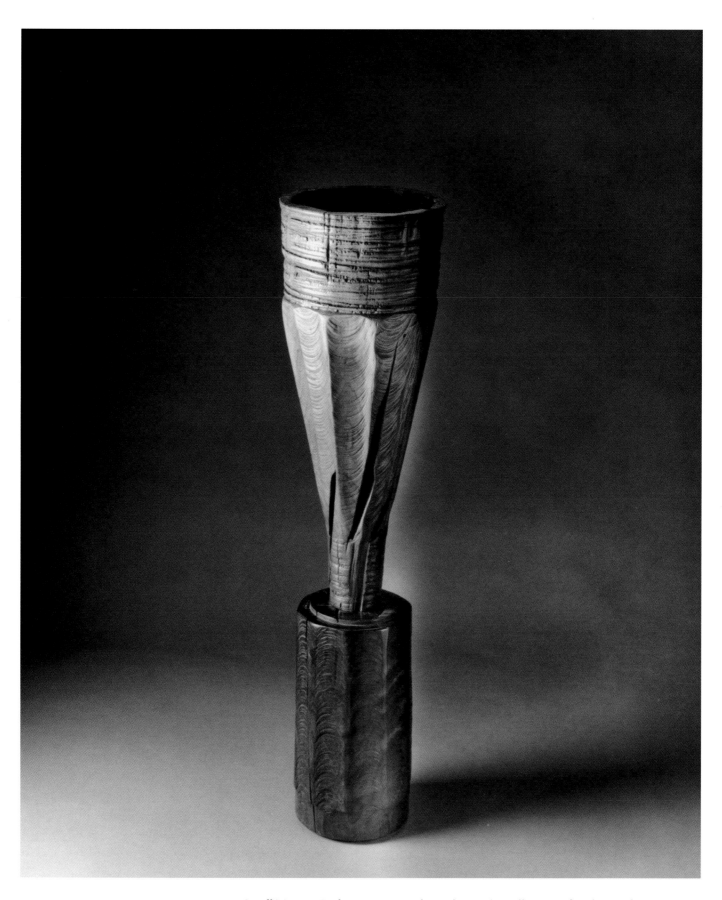

Small Totemic Sculpture, 1987, walnut, 45 x 11$\frac{1}{2}$, collection of Arthur and Jane Mason

Go Paul-Go, 1971, turned and carved vase, butternut, 9 x 5

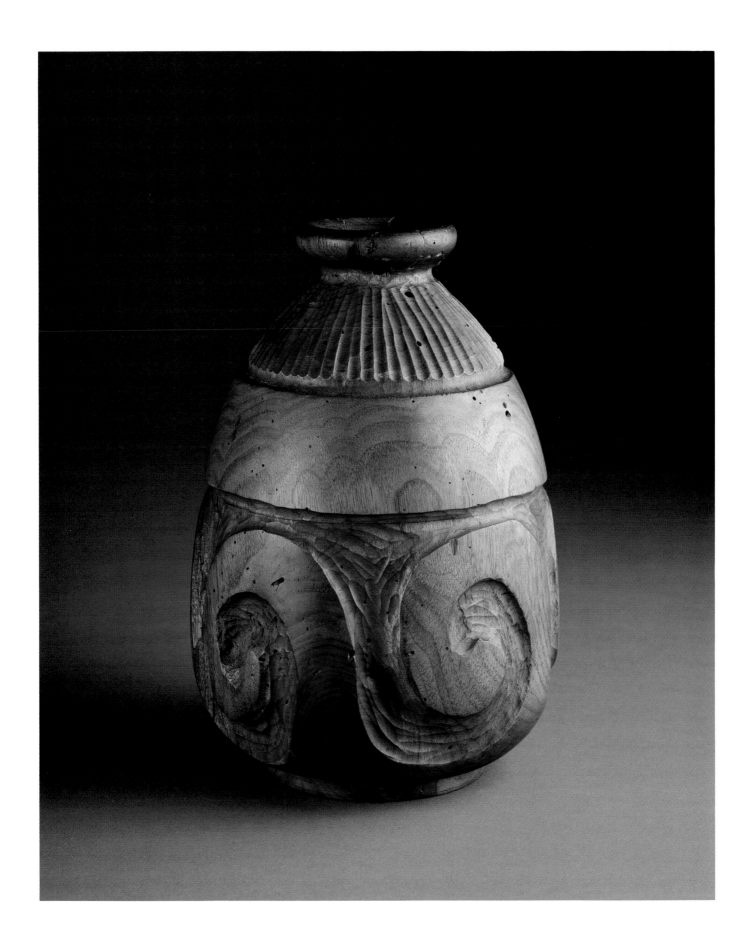

Meditating Vessel, 1972, white birch root burl, 4 x 7$\frac{1}{4}$

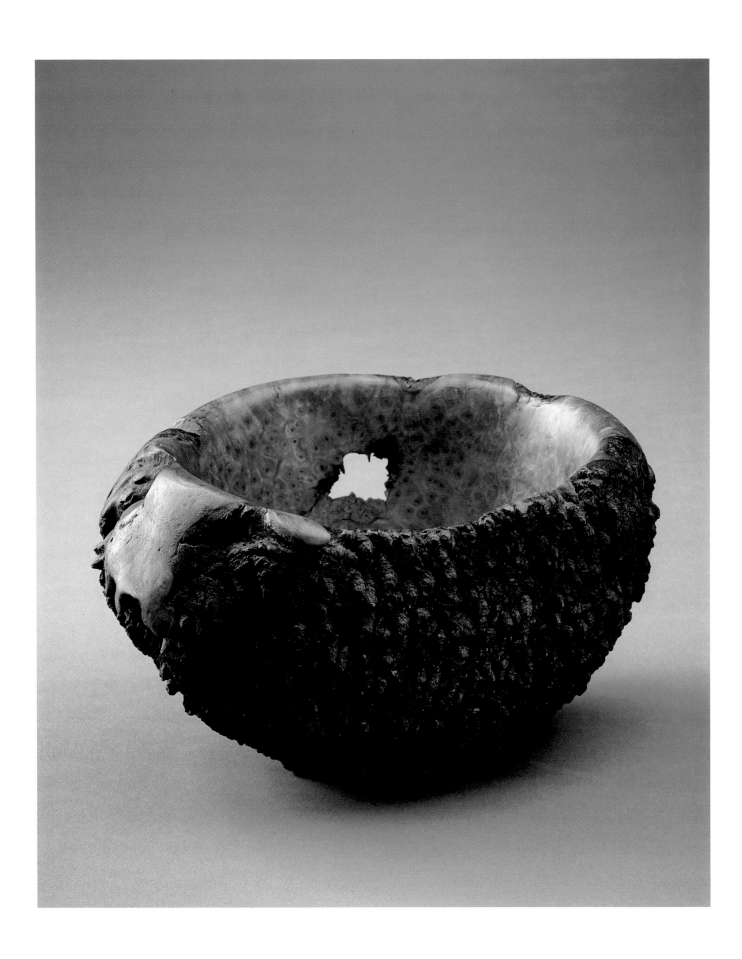

Turned Bowl, 1973, spalted yellow birch, 5^12 x 10, collection of Kathleen Lindquist

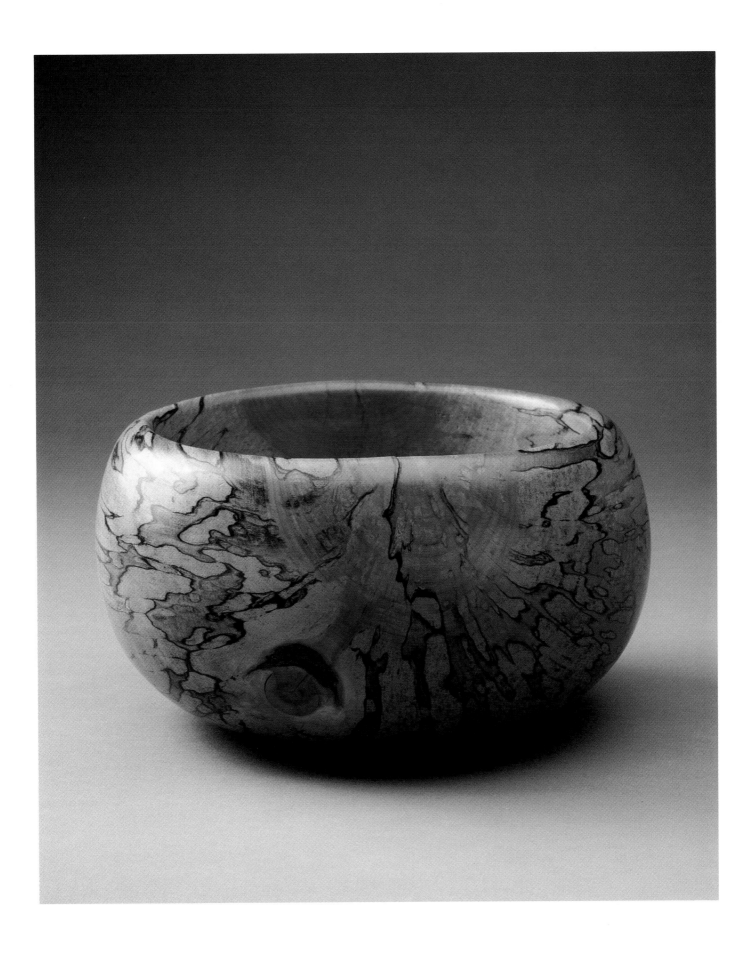

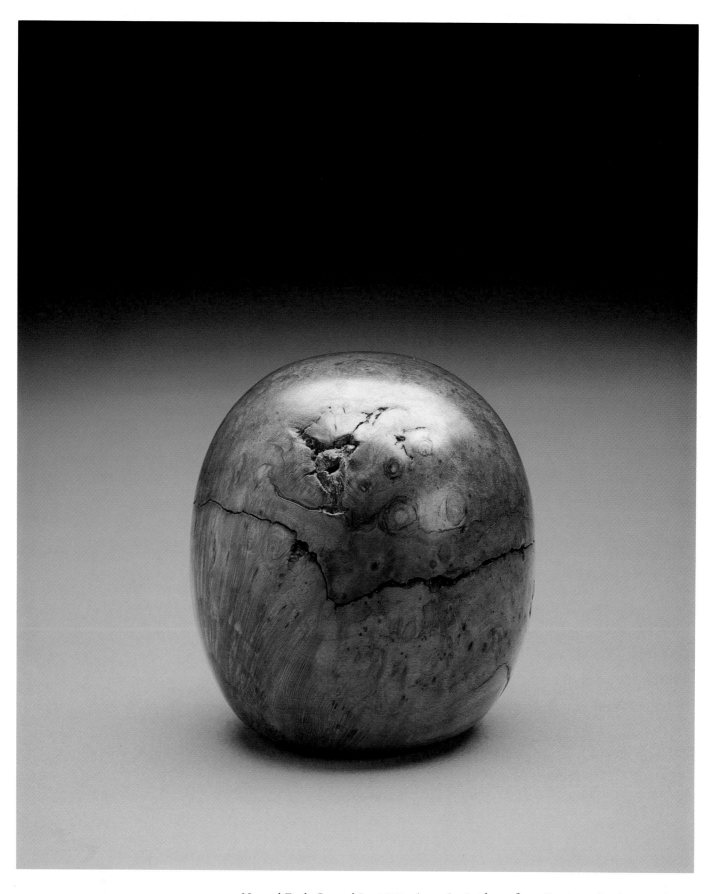

Natural Fault Covered Jar, 1975, cherry burl, 3^14 x 2^34, collection of Joshua Lindquist

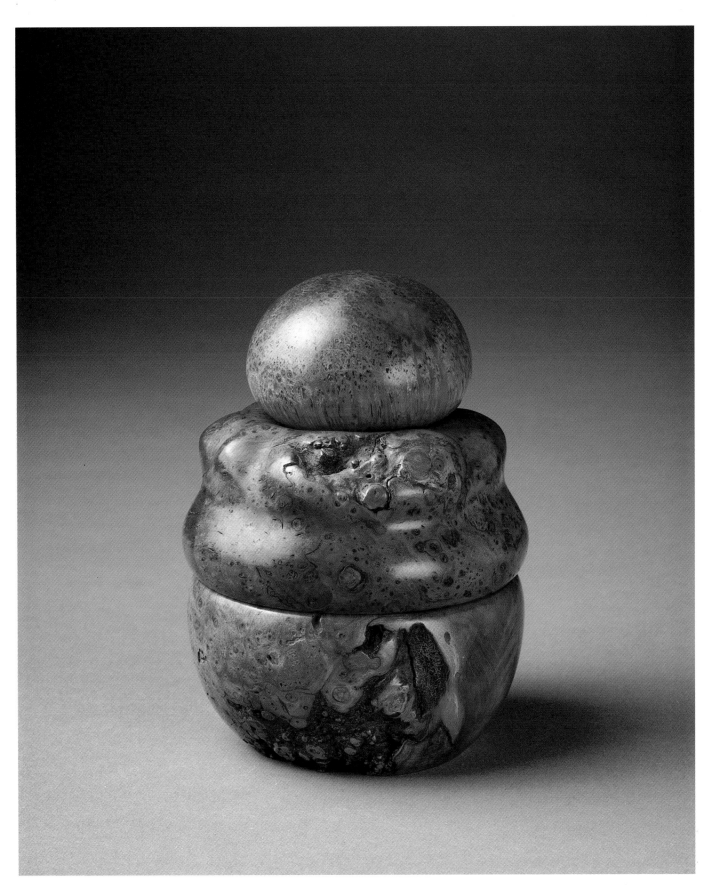

Turned and Carved Jar with Sphere Nesting on Top, 1975, cherry burl, $5^1$4 x 4, collection of Benjamin Lindquist

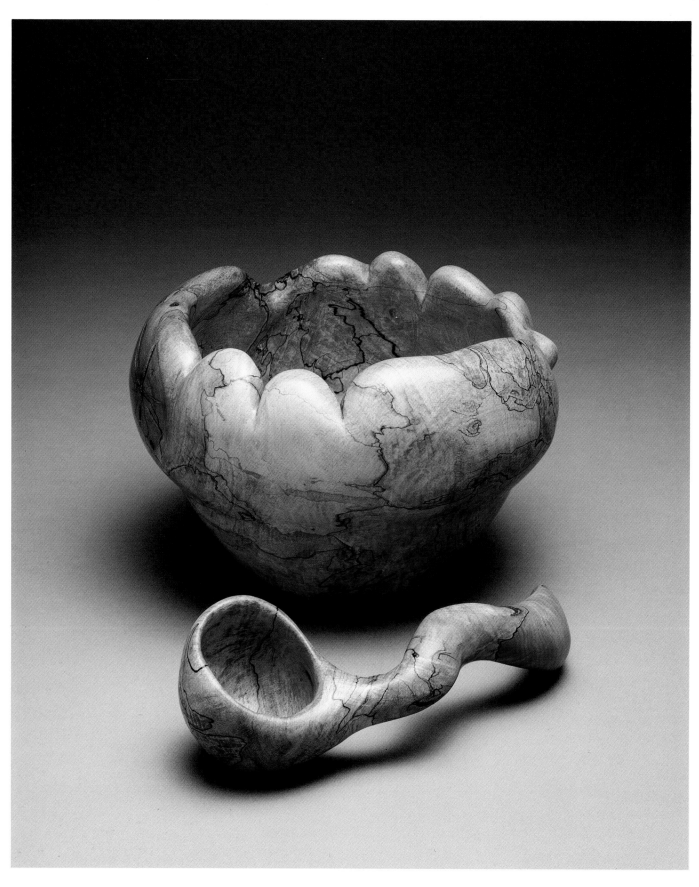

Turned and Carved Sculptural Bowl with Carved Spoon, 1975, spalted maple, 6¹4 x 8¹2, collection of Greenville County Museum of Art

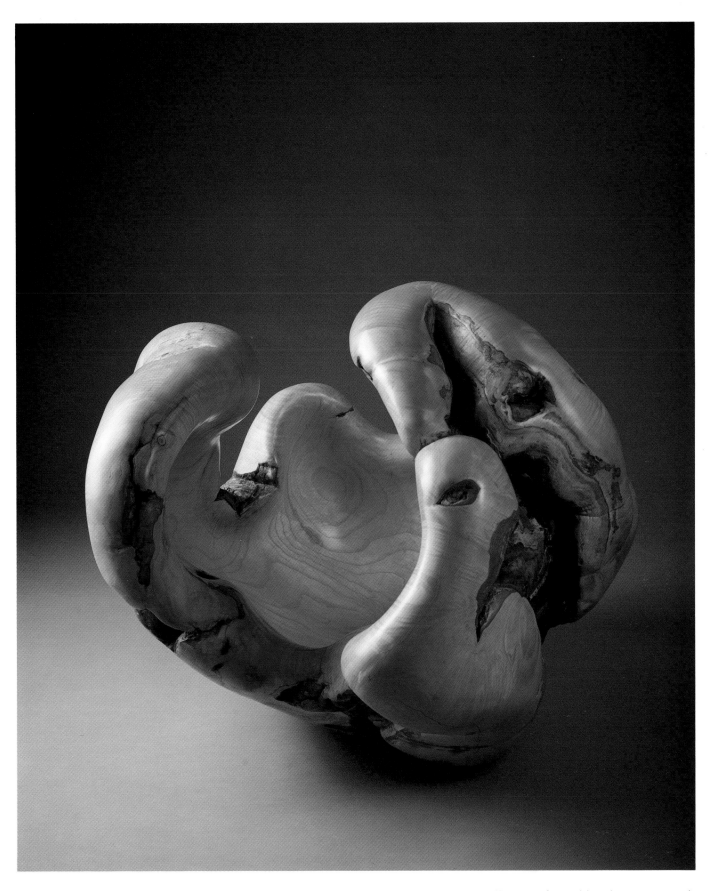

Sculptural Vessel, 1979, white ash burl, 24 x 20 x 26, collection of Ronald and Anita Wornick

Rolling Thunder, 1979, maple burl, 14 x 32, collection of Gary and Ruth Sams

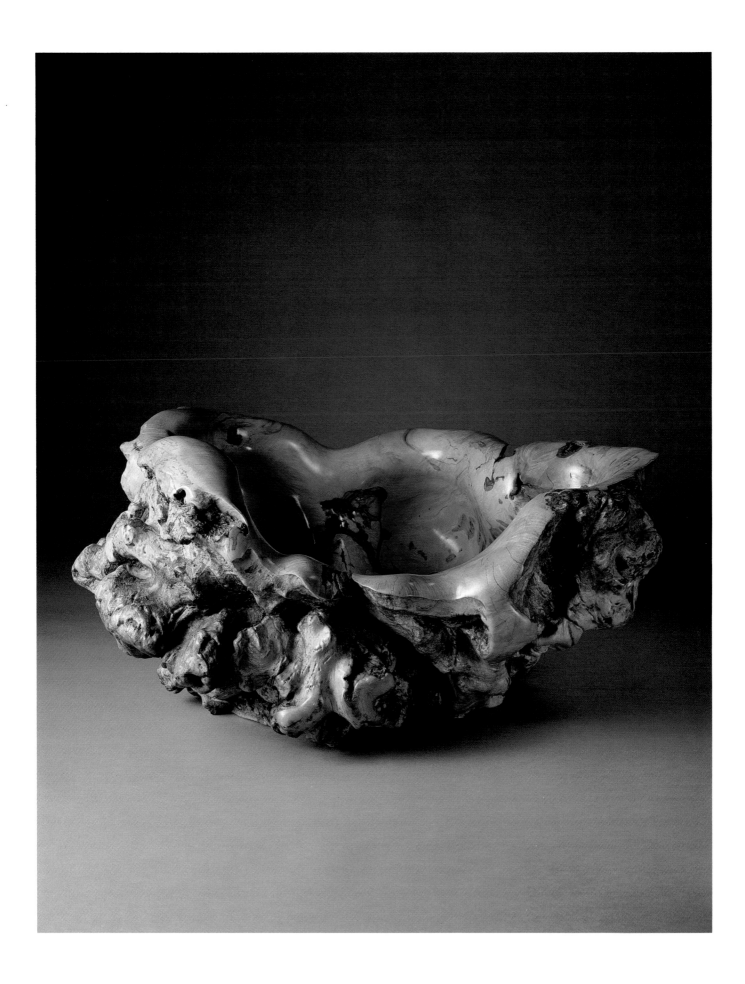

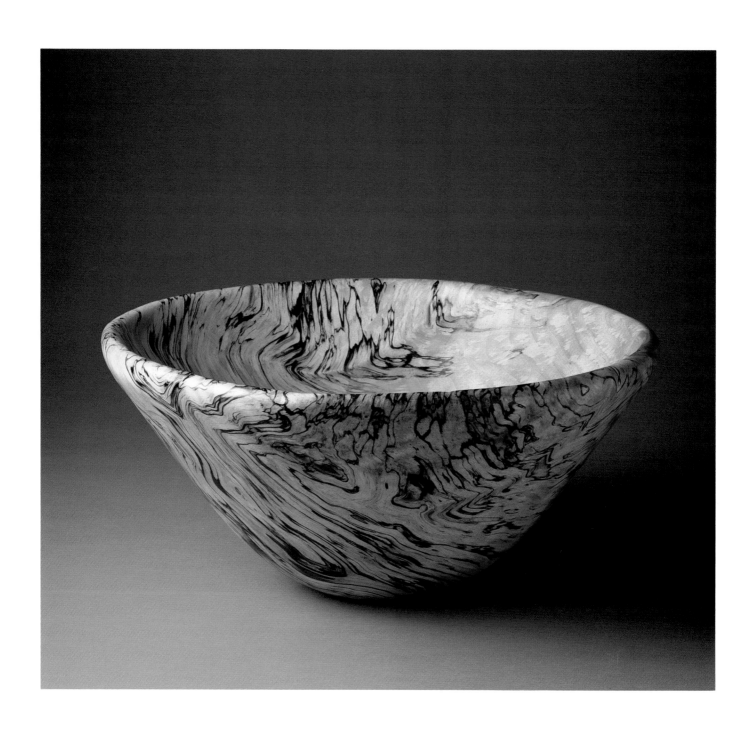

Turned Bowl, 1987, spalted yellow birch burl, 9 x 15^12, collection of Arthur and Jane Mason

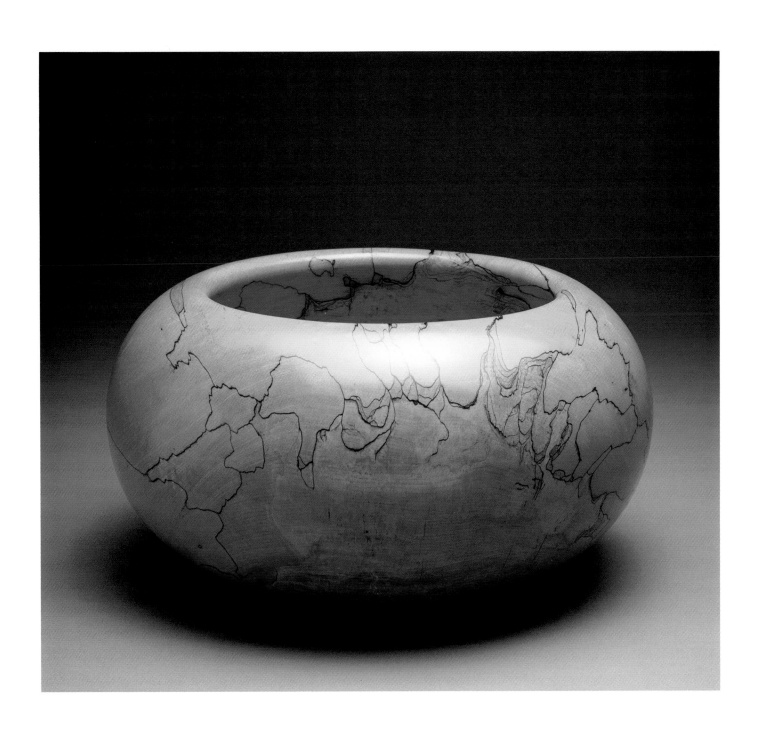

First-Fruit Bowl, 1979, spalted maple, 7¹4 x 14

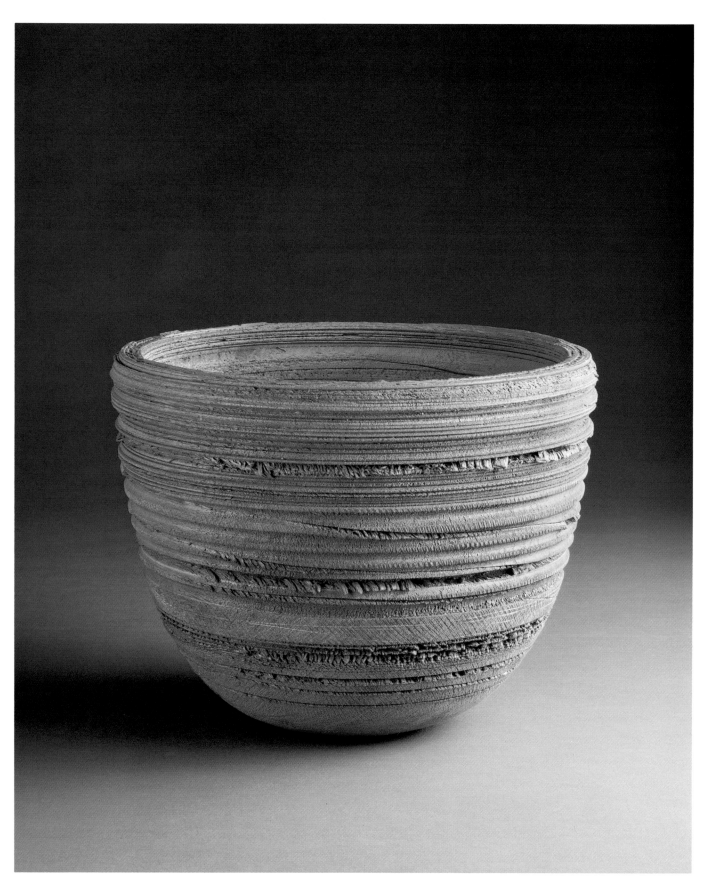

Amiran Krater, 1980, mahogany, 12 x 11, collection of Robert A. Roth

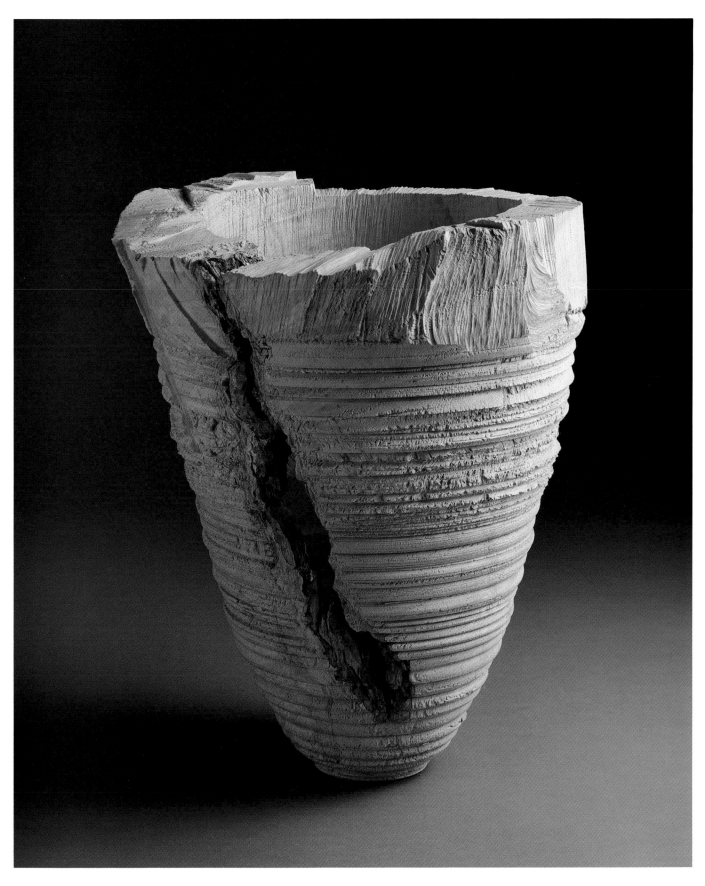

Ascending Bowl #5, 1981, spalted maple, 18 x 12, collection of Mr. and Mrs. Richard Winneg

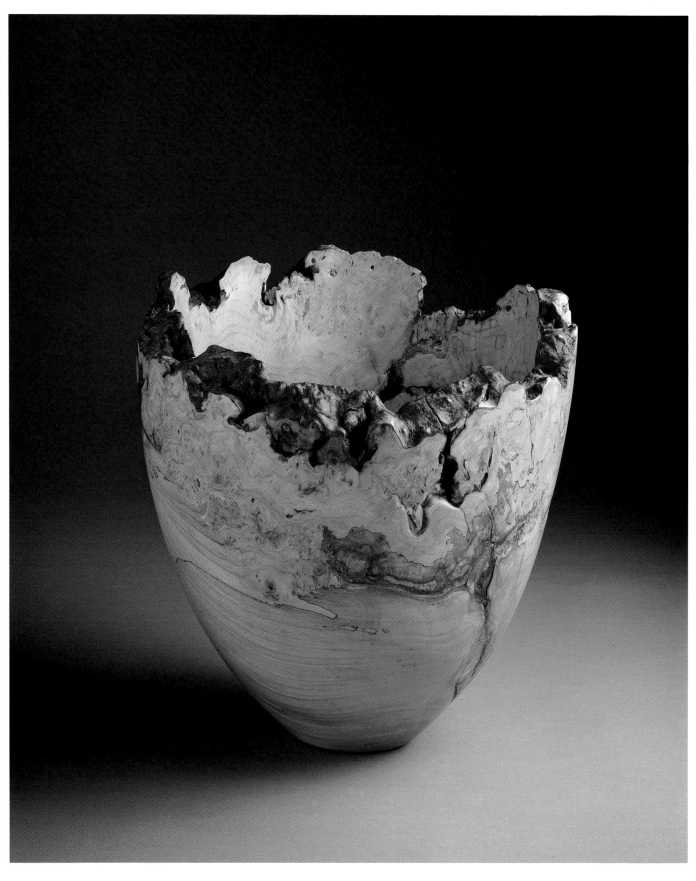

Spalted Elm Burl Natural Top Bowl, 1981, spalted elm burl, 16 x 12, collection of Arrowmont School of Arts and Crafts

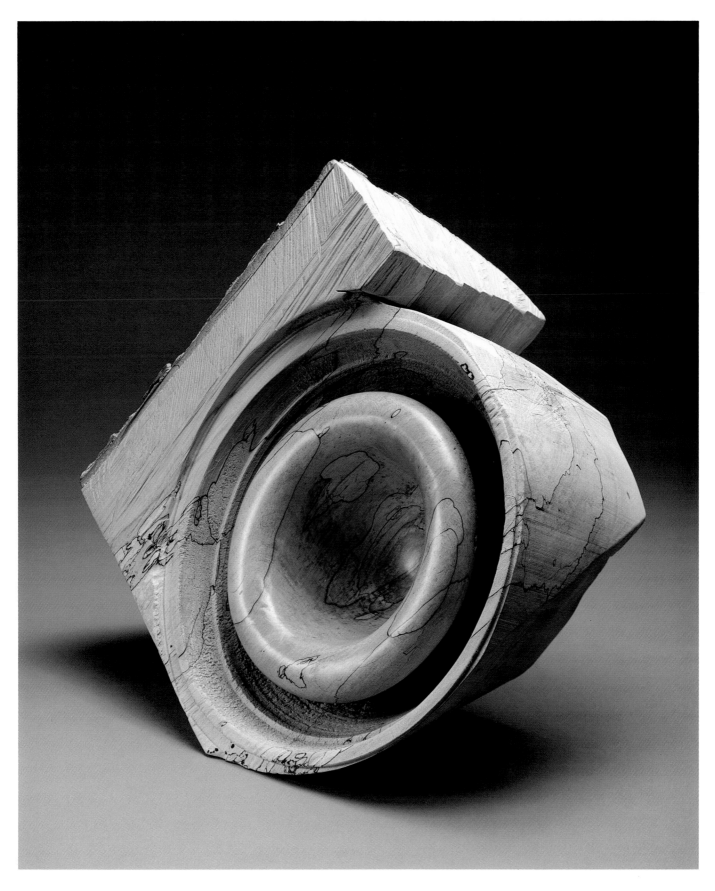

Evolutionary Bowl (Proto-Captive), 1982, spalted maple, 18 x 18, collection of Mr. and Mrs. Richard Winneg

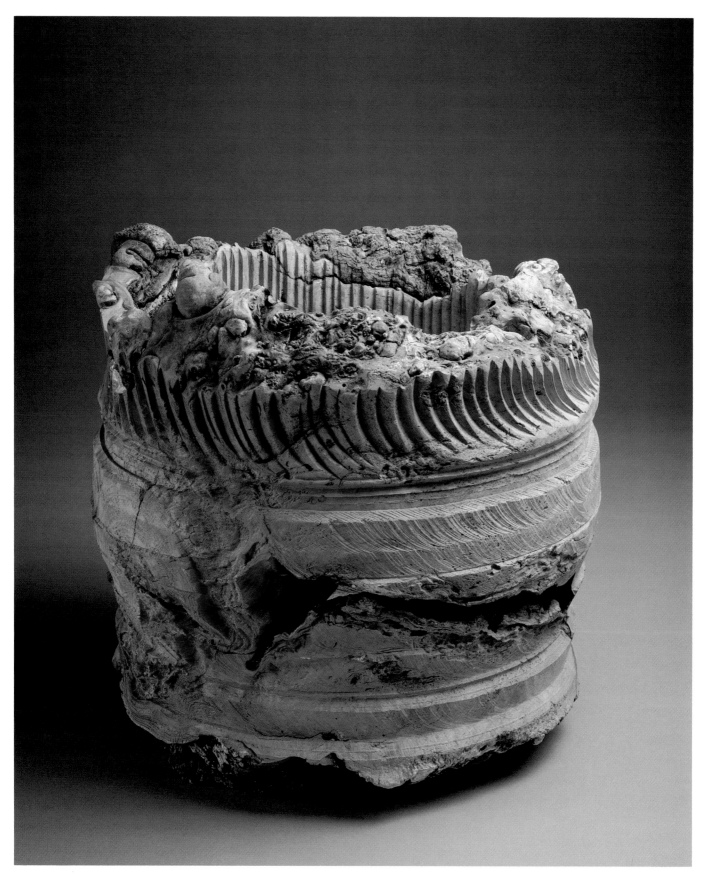

Nehushtan, 1982, cherry burl, 14 x 14, collection of Robert A. Roth

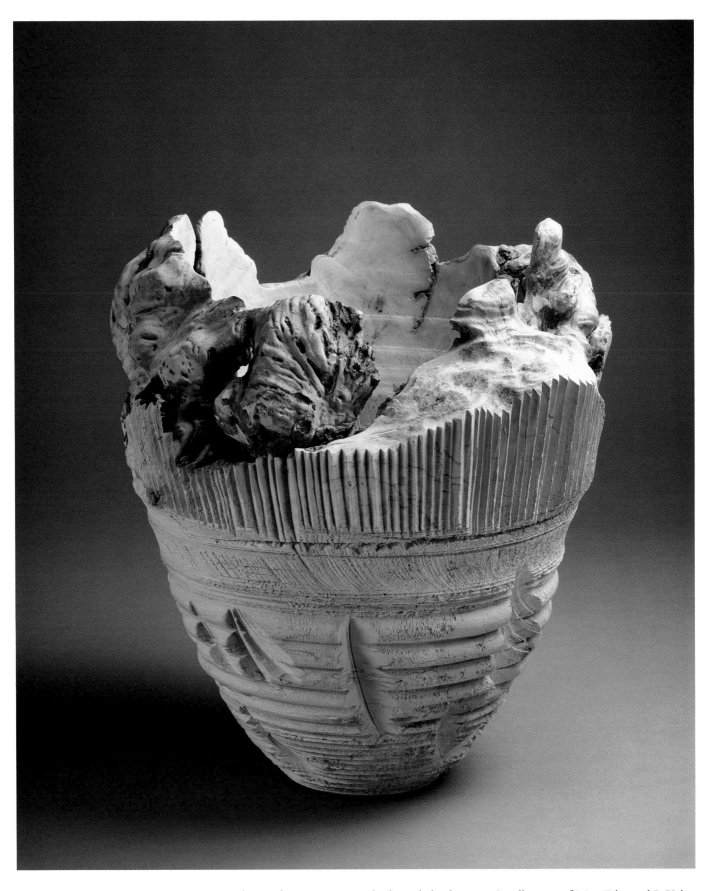

Unsung Bowl Ascending #1, 1982, spalted maple burl, 18 x 16, collection of Mrs. Edmund J. Kahn

Silent Witness #1, Oppenheimer, 1983, walnut, pecan, elm, 85 x 22, collection of Margaret A. Pennington

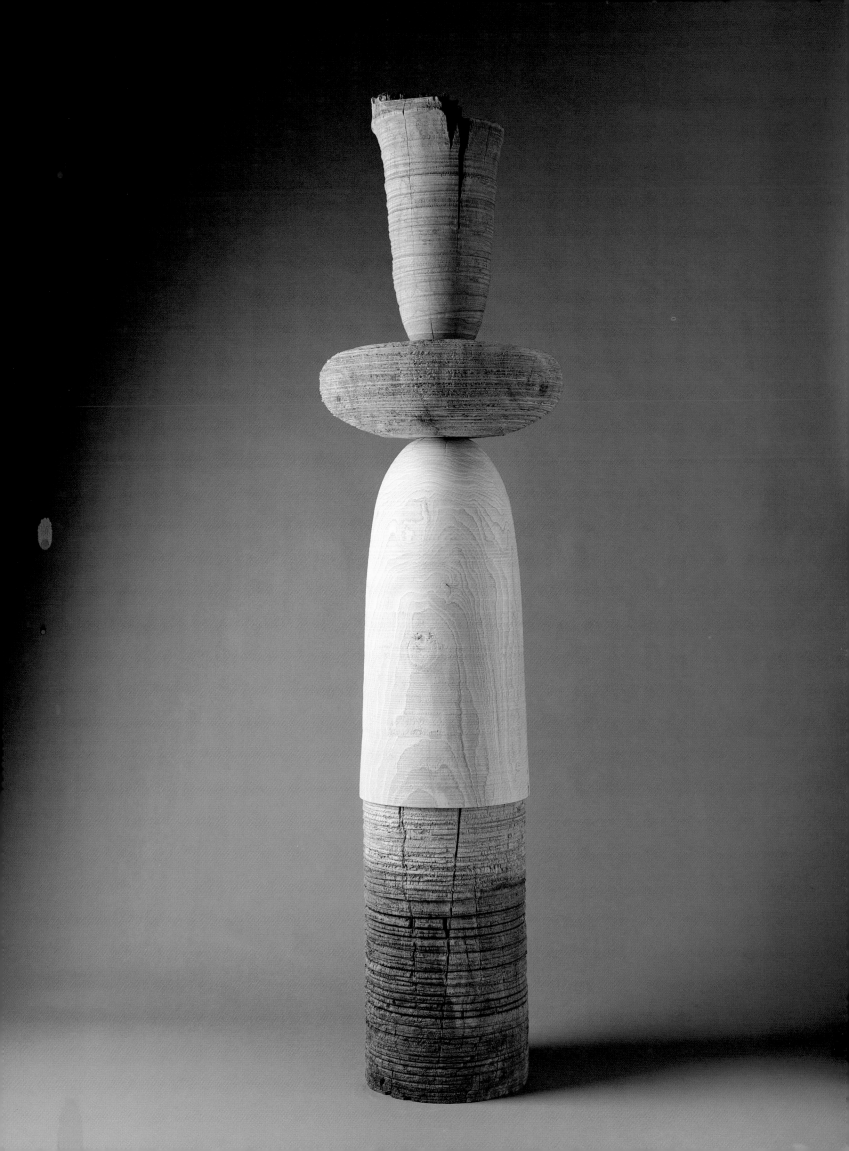

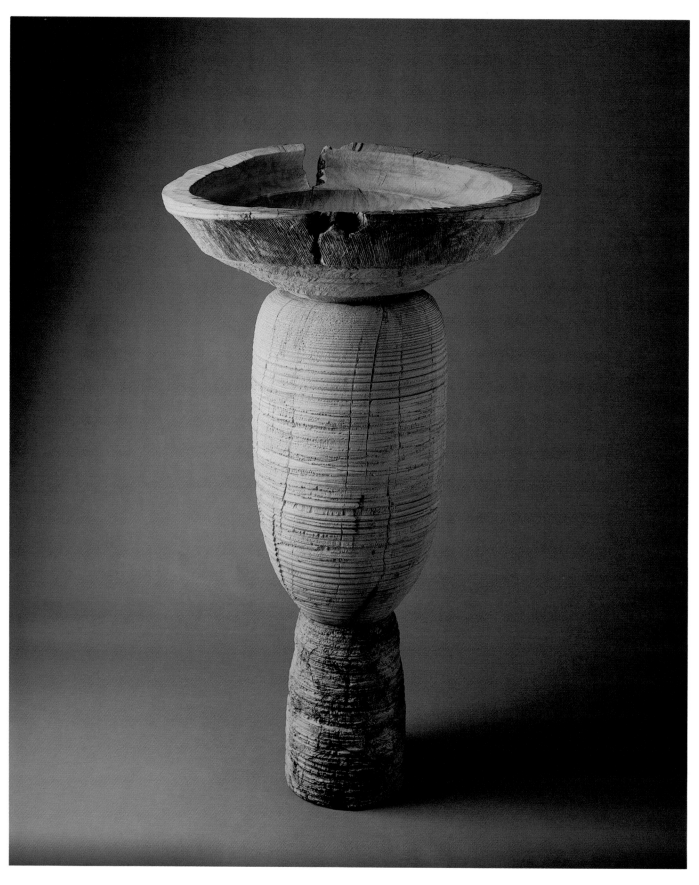

Toreador, 1984, spalted oak burl, maple burl, spalted maple, cherry burl, 60 x 30, collection of Ethan Allen Inc.

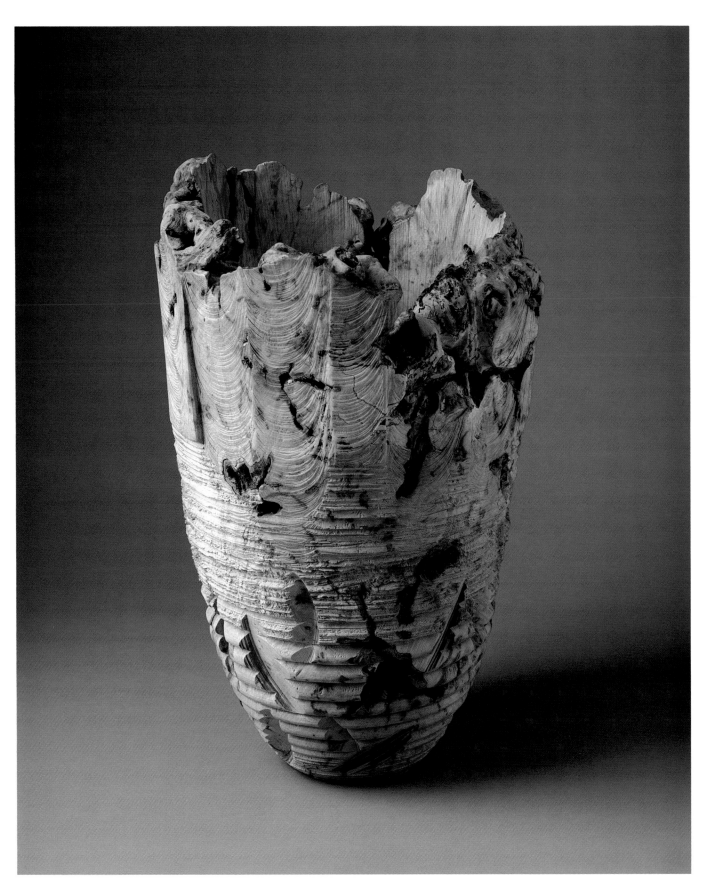

Chieftain's Bowl, 1985, spalted maple burl, 25$\frac{1}{2}$ x 17, collection of the Fuller Museum of Art

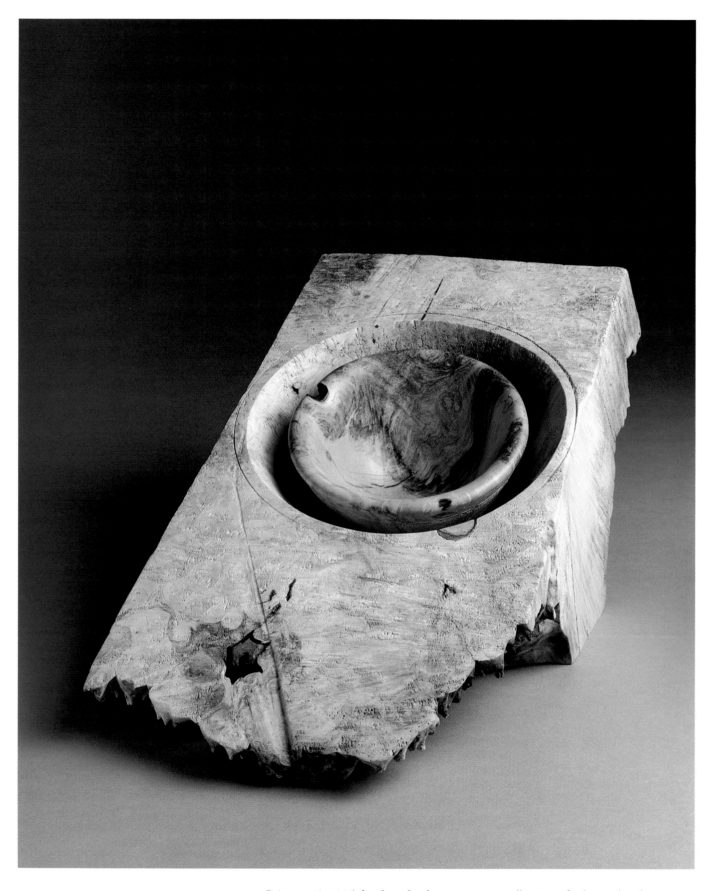

Prisoner #3, 1986, buckeye burl, 8 x 10 x 18, collection of John and Robyn Horn

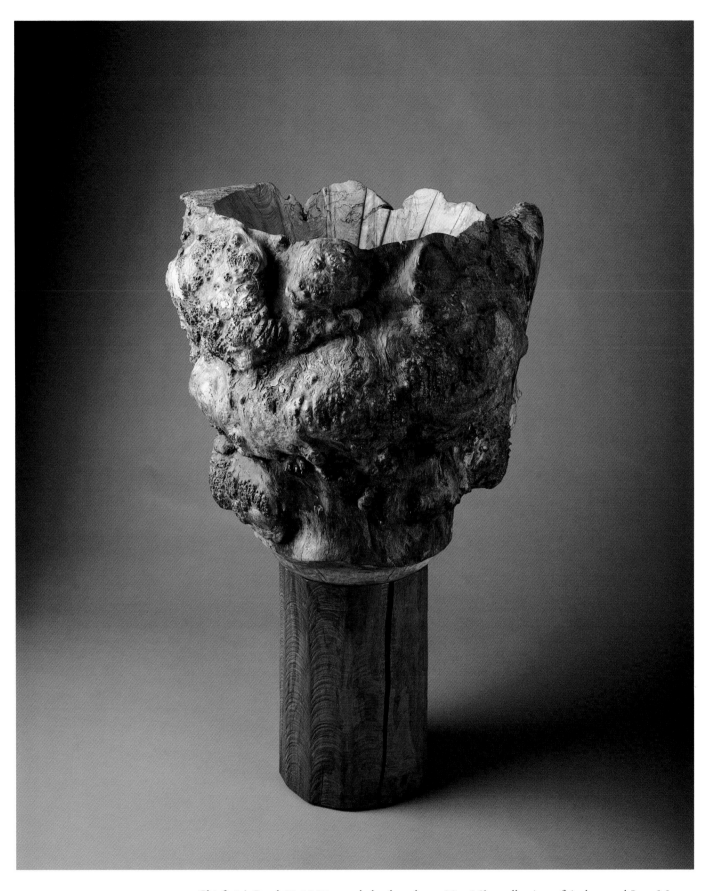

Chieftain's Bowl #3, 1987, maple burl, walnut, 38 x 25^12, collection of Arthur and Jane Mason

Mongaku, 1989, cherry, polychrome, 75 x 18

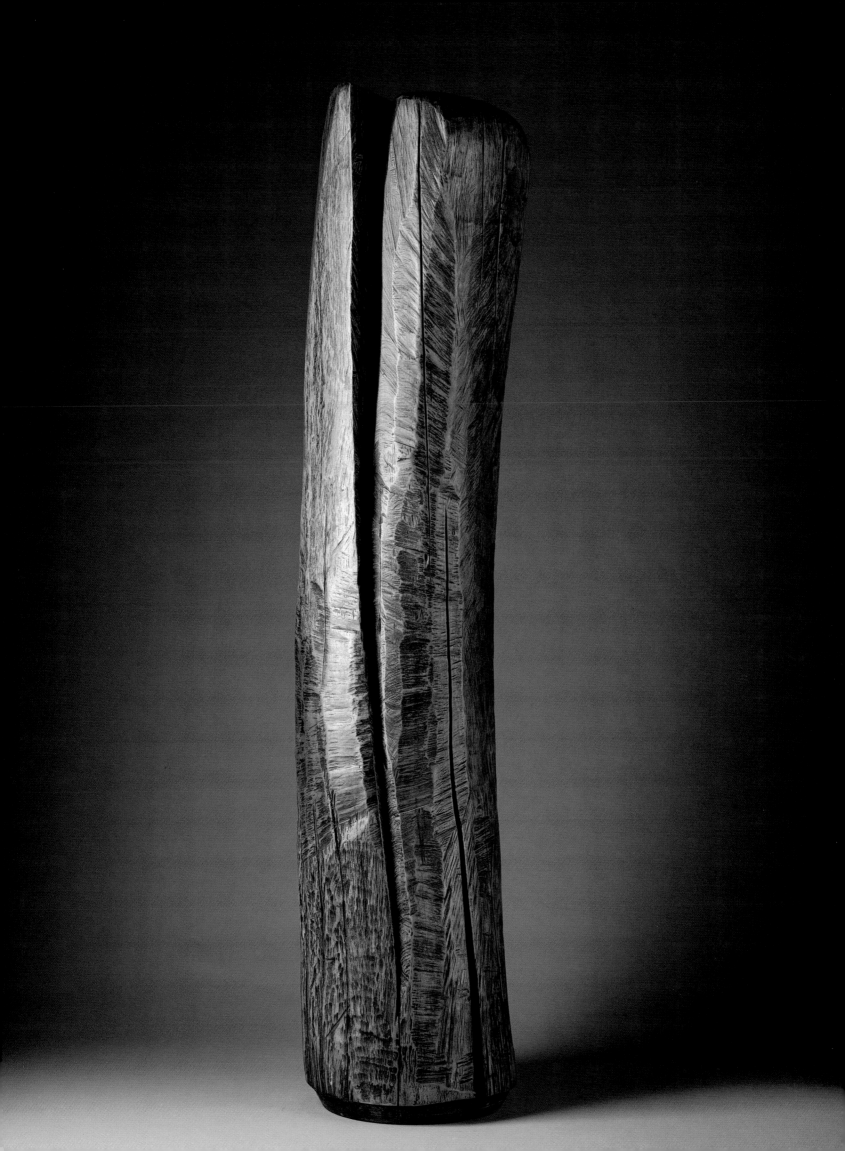

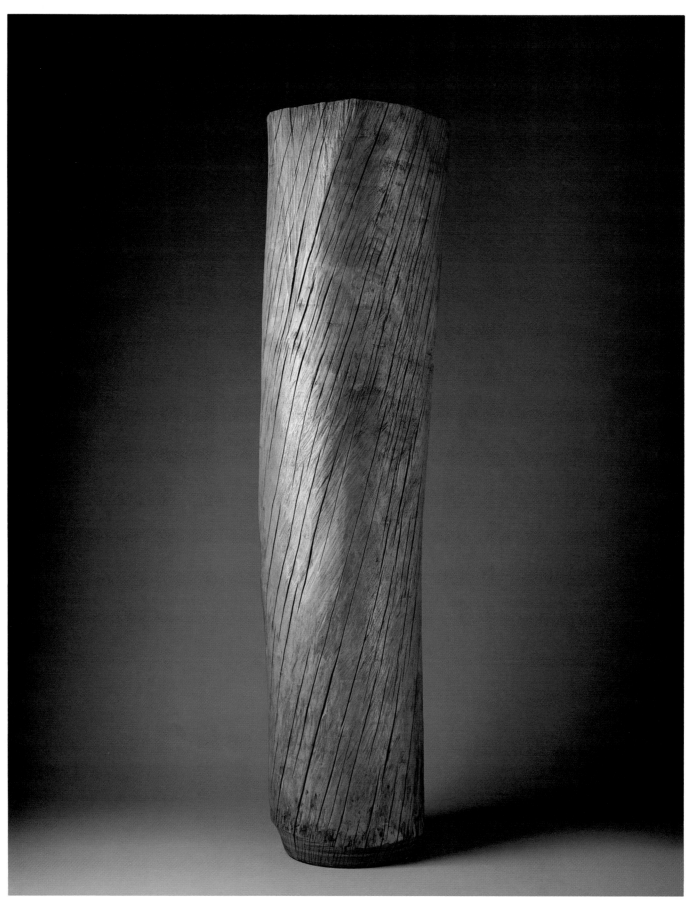

Natabori, 1989, cherry, polychrome, 75 x 24

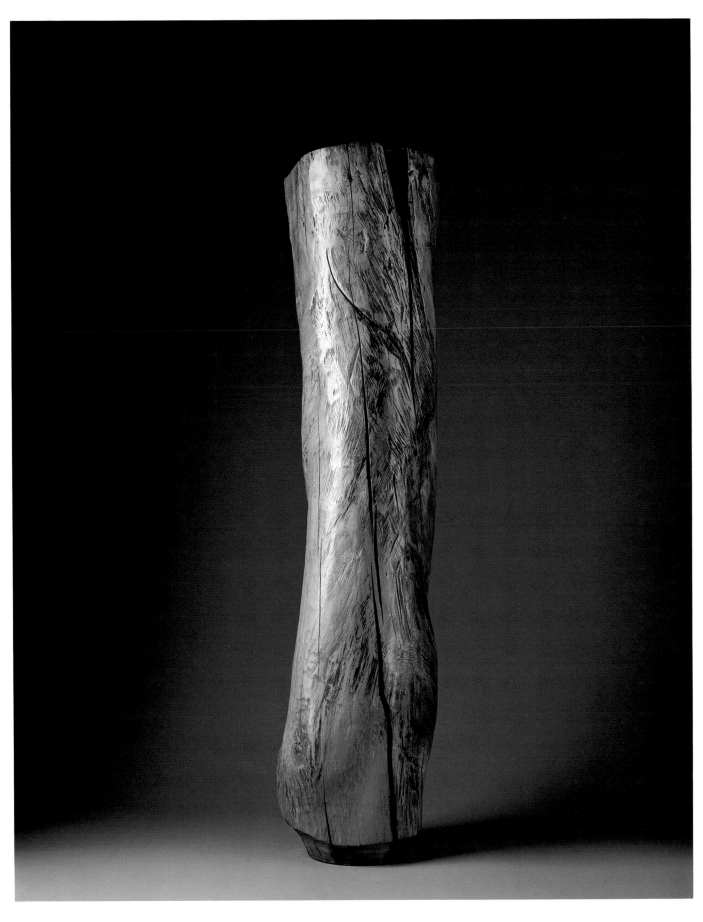

Akikonomu, 1989, cherry, polychrome, 73½ x 22, collection of Arthur and Jane Mason

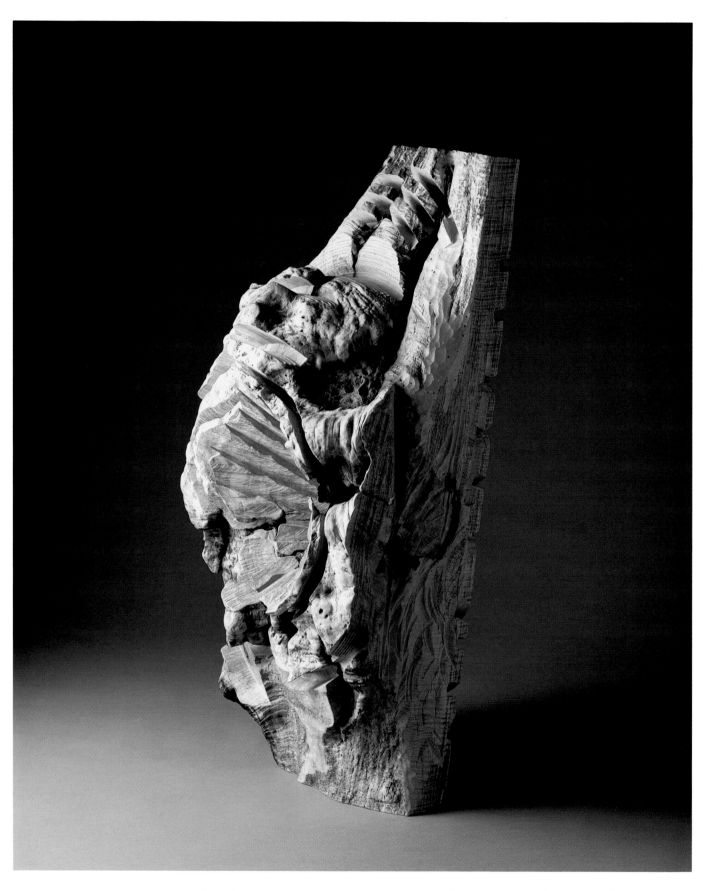

Ascending Captive #1, 1992, maple burl, 30 x 14 x 9, collection of John and Cheryl Ferguson

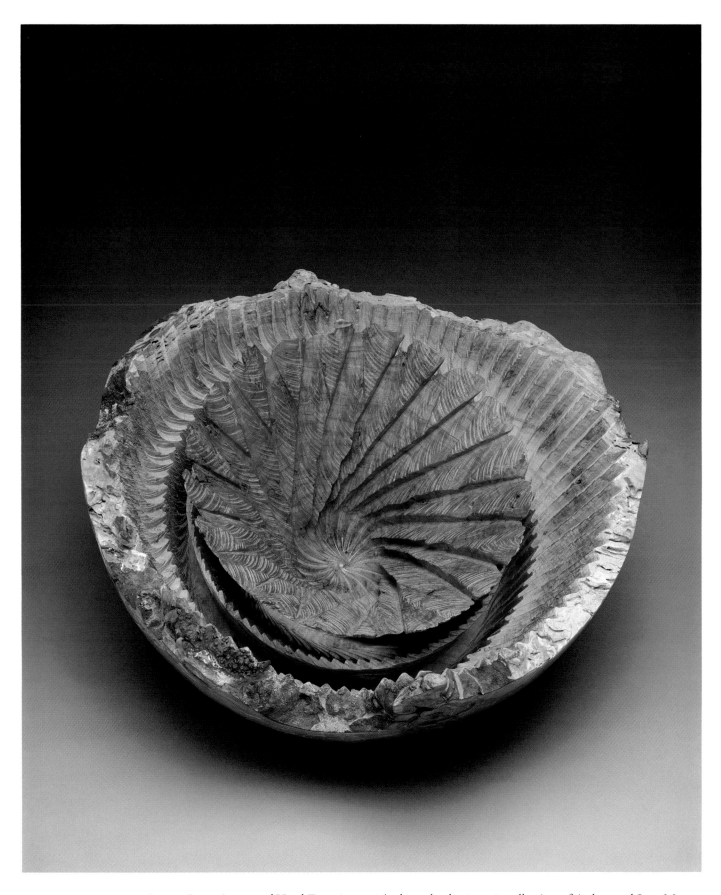

Ancient Inner Anagogical Vessel Emerging, 1994, cherry burl, 12 x 18, collection of Arthur and Jane Mason

Chronology

1949 Born May 16 in Oakland, California, to Helen Lilly Lindquist and Melvin Lindquist. Melvin, an electrical engineer and master machinist, works for the General Electric Company during the day and creates vases in his woodturning shop at home during the evenings. Mark has one older sister, Catherine.

1954 Melvin Lindquist is transferred by General Electric and the Lindquist family relocates to Schenectady, New York. Melvin builds his woodturning studio in the basement of their new house, and at the same time creates a small workshop for Mark. Over the next ten years, Melvin teaches Mark woodworking and mechanics, Mark observes his father woodturning, and they work together on projects such as building racers, go-karts, and motorized bikes.

1956 Melvin purchases 93 acres of land in Chestertown, New York, in the Adirondack Mountains. Over the next ten years, Melvin and Mark visit this land on weekends and in the summer, building a log cabin, clearing trails, and gathering wood for turning. It is on this land that they first discover spalted wood.

1959 Begins woodturning and using the chain saw.

1967 Becomes engaged to his high school sweetheart, Kathleen Bragg. Graduates from Niskayuna High School; enters New England College in Henniker, New Hampshire.

1968 Marries Kathleen Bragg, who plays a major supportive role in the development and continuity of Mark's career.

1969 Builds house and studio on Patch Road in Henniker, next to the "Cascades" waterfalls. Meets and begins dialogue with Darr Collins, potter and interim art instructor at New England College. Works with John McAlevy, local furniture-maker.

1970 Receives grant to create metalworking studio for the college and to learn metal sculpture. Studies welding with maintenance personnel. Makes large-scale metal sculptures. Begins part-time apprenticeship with Darr Collins. Sets up woodturning studio in house and begins turning again, translating ceramic forms into wood using the Shopsmith his father gave him. Introduces into woodturning the concept of the "happy accident," incorporating spalting, natural tops, holes, and cracks as potters use sgraffito and accept glaze crackling and irregularities.

1971 First child, Benjamin, is born in March. (From an early age through mid-high school, Ben works with his father, learning woodworking and participating in all aspects of the studio.) Graduates from New England College; receives Creative Arts Award. Enters into full-time

apprenticeship with Darr Collins, which is interrupted for three months when Mark enters Pratt Institute's M.F.A. Program and is then resumed when he leaves Pratt. Assists Collins in building studio, kiln, and kickwheels.

1972 Mark, Kathy and Ben spend two months with Mark's parents in Schenectady. Mark and Melvin work together in Melvin's studio. After returning to Henniker, Mark resumes his apprenticeship with Collins. Joins his father in showing woodturning at regional craft fairs.

1973 Begins exhibiting in craft galleries: The Place, Pound Ridge, New York, Julie:Artisan's Gallery in New York City, Ten Arrow Gallery in Cambridge, Massachusetts, and Fairtree Gallery, New York City. With his father, exhibits at American Craft Council (ACC) Northeast Craft Fair, the year this fair, which becomes ACC's premier craft marketing event, moves to Rhinebeck, New York. Melvin and Mark continue to exhibit at Rhinebeck every year through the last Rhinebeck Fair in 1983.

1975 Second child, Joshua, is born in February. (From an early age through high school, Josh works with his father, learning woodworking and participating in all aspects of the studio.)

1977 Writes article on spalted wood which is published in *Fine Woodworking* magazine. Mark's work is included in the *Young Americans: Fiber, Wood, Plastic, Leather* show of the Museum of Contemporary Crafts of the American Crafts Council in New York City. Becomes American Crafts Council Northeast Region Representative, a position which he holds until 1980 when the council becomes a national organization. In the fall, becomes Head of Woodworking for the Worcester (Mass.) Craft Center. Moves with his family to Worcester where they stay until the summer of the following year.

1978 Acquisition of two pieces, the *Lapping Wavelet Bowl* and the *Brancusi Cup*, by the Metropolitan Museum of Art in New York City. Penelope Hunter-Stiebel, Curator of Twentieth Century American Decorative Arts, introduces Mark to the work of James Prestini. *The Art of the Turned Bowl*, an exhibit of the works of Melvin and Mark Lindquist, Ed Moulthrop, and Bob Stocksdale, opens at the Renwick Gallery of the Smithsonian Institution, Washington, DC. Meets sculptor Will Horwitt; begins friendship and exchange of visits between Mark's New Hampshire studio and Horwitt's Tribeca, New York City studio; assists Horwitt with woodworking techniques and photography, produces a catalog of Horwitt's work. Mark and Will carry on a dialog about work and life until Horwitt's death in 1985. Writes article on turning spalted wood for *Fine Woodworking* magazine.

1979 Work included in *New Handmade Furniture* at the American Craft Museum in New York. Lectures at the Renwick Gallery of the Smithsonian Institution. Establishes the woodturning program at the Haystack Mountain School of Crafts in Maine. Creates his first *Ascending*

Bowl, which marks his decisive departure from smooth-surface vessels. One-person exhibition at Greenville County Museum of Art, Greenville, South Carolina: ten-year overview. Sculpture *Forbidden Fruit Tree (DeFunctional Sculpture)* acquired by the Greenville County Museum of Art. Begins acquiring, refurbishing, and refitting large early industrial-age machinery for innovative woodturning techniques.

1980 Spends the months of February and March as a fellow at the MacDowell Colony in Peterborough, New Hampshire. Creates environmental sculpture, *The MacDowell Woodpiles*. One-person show of *Zone-Line* and other photographs at Kendall Art Gallery in Wellfleet, Massachusetts.

1981 Initiates the woodturning program at Arrowmont School of Arts and Crafts, Gatlinburg, Tennessee. The National Museum of American Art purchases Mark's *Ascending Bowl #3*, the first turned wood object acquired by the museum since its acquisition of several Prestini bowls. Creates *MacDowell Bowl*, the first large-scale completely chain saw lathe-turned bowl.

1982 Invents incremental chain saw/lathe plunge-cutting technique, a furtherance of the cone separation technique. At request of Sandra Blain, Director, and Robert Skinner, Business Administrator, designs woodturning studio addition for Arrowmont School.

1983 Purchases twenty acres in rural Quincy, Florida, with abandoned tobacco packing plant and tobacco barn. Begins creating home and studio. Continues to maintain New Hampshire home and studio until 1986, when he and his family relocate permanently to Quincy. Begins series of large turned wood sculptures (6' to 8' in height) that he calls *Totemic Series* sculptures.

1984 First one-person show of *Totemic Series* sculptures, At the Quadrangle, HumanArts Gallery, Dallas. Develops, with Sandra Blain and David Ellsworth, plans for the first National Woodturning Conference, which is held at the Arrowmont School in October of 1985. Organizes first awards honoring pillars of studio woodturning movement.

1985 Survives serious automobile accident en route to Baltimore. As a result, gradually adjusts to new slower pace in life and work. Sculpture in the *Totemic Series*, *Ancient Monolith #1*, acquired by the Dallas Museum of Art.

1986 Exhibits in *Ob'Art*, Les Ateliers d'Art, Paris, France at special invitation of the French delegation to the ACC's 1985 West Springfield Fair. Visits museums (including Brancusi Museum in Paris) and travels in France, Switzerland and Luxembourg. Mark's book, *Sculpting Wood*, is published by Davis Press.

1987 Teaches drawing and design at Florida A&M University School of Architecture.

1988 Enters Florida State University M.F.A. Program. Studies Japanese art history with Dr. Penelope Mason. Begins *Ichiboku* series of large wood sculptures inspired by ancient Japanese Heian sculpture. Begins series of *Stratigraphs and De-Compositions*, carved paintings on plywood.

1989 In the summer, Mark and Kathy travel west to New Mexico, visiting Chaco Canyon, and Acoma and other pueblos. Included in *The Grand Masters of Woodturning*, Franklin Parrasch Gallery, Washington, DC. One-person show of sculpture at Franklin Parrasch Gallery reviewed in *Art in America*. Receives Southern Arts Federation/National Endowment for the Arts Fellowship Award.

1990 Receives M.F.A. from Florida State University. One-person show of painted reliefs at Franklin Parrasch Gallery in New York, NY. Travels to Paris, Barcelona, and Valencia, visiting museums. Takes on Roger A. Paph as artist's assistant; begins rebuilding machines as primitive robotics.

1991-93 Concentrated period of research and design, reconfiguring studio, and building robotics. Begins *Les Couches Découvertes* series of painted reliefs.

1993 Work acquired by the White House for the first White House Craft Collection. Installation of *Totemic Triad* commissioned (through Hodges Taylor Gallery) by Nation's Bank for its new corporate headquarters in Charlotte, North Carolina. Gail Severn Gallery has one-person show of Mark's work at the *Chicago International New Art Forms Exposition*.

1994 Gail Severn Gallery shows Mark's work concurrently with Dale Chihuly's in two one-person shows at the first *International Exposition of Sculpture, Objects & Functional Art (SOFA)* in Chicago.

1995 Included in the National Museum of American Art's exhibition, *The White House Collection of American Crafts*. Gail Severn Gallery has one-person show of Mark's work at the first Miami *International Exposition of Sculpture, Objects & Functional Art*.

Exhibitions

Selected One-Person Shows

1974 Ten Arrow Gallery, Cambridge, MA

1975 Florence Duhl Gallery, New York, NY

1977 Incorporated Gallery, New York, NY

1979 *Mark Lindquist: Works in Wood,* Greenville County Museum of Art, Greenville, SC
Jackie Chalkley Gallery, Washington, DC

1980 Kendall Art Gallery, Wellfleet, MA

1981 *Mark Lindquist: Recent Work in Wood,* The Hand and the Spirit Gallery, Scottsdale, AZ

1982 *Featured Object May/June,* National Museum of American Art, Renwick Gallery,
Smithsonian Institution, Washington, DC
Mark Lindquist: Recent Innovations/Burl and Spalted Wood, American Art, Inc., Atlanta, GA

1984 *Totemic Series Sculptures,* At the Quadrangle, HumanArts Gallery, Dallas, TX

1985 Image of Sarasota, Sarasota, FL

1986 Brevard Art Center and Museum, Melbourne, FL
Snyderman Gallery, Philadelphia, PA

1987 School of Architecture, Florida A&M University, Tallahassee, FL
Mark Lindquist: Wood Sculpture, Gail Severn Gallery, Ketchum, ID
Prisoners: New Sculpture, Snyderman Gallery, Philadelphia, PA

1988 *Mark Lindquist: Sculpture,* Mendelson Gallery, Washington Depot, CT

1989 Franklin Parrasch Gallery, New York, NY

1990 *Mark Lindquist: Stratigraphs and De-Compositions,* Franklin Parrasch Gallery, New York, NY
Mark Lindquist: Recent Works, The Tallahassee Gallery, Tallahassee, FL

1991 *Mark Lindquist: New Works,* Mendelson Gallery, Washington Depot, CT
Mark Lindquist: Painted Reliefs, Gail Severn Gallery, Ketchum, ID

1992 Snyderman Gallery, Philadelphia, PA

1993 *Chicago International New Art Forms Exposition* (Gail Severn Gallery)
 Mark Lindquist: Sculpture, Delaware Art Museum, Wilmington, DE
 Dorothy McRae Gallery, Atlanta, GA
 Dorothy Weiss Gallery, San Francisco, CA
 Mark Lindquist: Sculpture, Indigo Gallery, Boca Raton, FL

1994 *The International Exposition of Sculpture, Objects & Functional Art,* Chicago, IL
 (Gail Severn Gallery)

1995 *The International Exposition of Sculpture, Objects & Functional Art,* Miami, FL
 (Gail Severn Gallery)

Selected Group Shows

1973 Julie:Artisan's Gallery, New York, NY

1974 Fairtree Gallery, New York, NY

1975 *Mark and Melvin Lindquist,* The Elements, Greenwich, CT
 Bed and Board, DeCordova Museum, Lincoln, MA
 Florence Duhl Gallery, New York, NY

1976 *The Handwrought Object, 1776-1976,* Herbert F. Johnson Museum of Art,
 Cornell University, Ithaca, NY
 The Schenectady Museum, Schenectady, NY
 Marietta College Crafts National, Grover M. Hermann Fine Arts Center, Marietta, OH
 Forms in Wood, Florence Duhl Gallery, New York, NY

1977 *Young Americans: Fiber, Wood, Plastic, Leather,* Museum of Contemporary Crafts of the
 American Crafts Council, New York, NY
 Celebration Northeast, Dartmouth College, Hanover, NH
 The Grand Opening Show, The Elements Gallery on Madison Avenue, New York, NY
 The Handmade Object, The Hand and the Spirit Gallery, Scottsdale, AZ
 Two Generations, The Craftsman's Gallery, Scarsdale, NY

1978 *The Art of the Turned Bowl,* Renwick Gallery, Smithsonian Institution, Washington, DC

American Wood, Makers Gallery, New York, NY

American Woodcarvers, Worcester Craft Center, Worcester, MA, and Warner Communications, Rockefeller Center, New York, NY

Meyer Breier Weiss, San Francisco, CA

Mark Lindquist and Melvin Lindquist, The Works Gallery, Philadelphia, PA

1979 *New Handmade Furniture,* American Craft Museum, New York, NY (& travelling)

Wood and Fiber, Edward Bannister Gallery, Rhode Island College, Providence, RI

Young Americans, Museum of Contemporary Crafts, New York, NY (& travelling)

Craft Alliance Gallery, St. Louis, MO

1980 *For the Tabletop,* American Craft Museum, New York, NY (& travelling)

New Hampshire Crafts Biennial, Manchester Institute of Arts and Sciences, Manchester, NH

1981 *Art in Craft Media,* Bowdoin College Museum of Art, Brunswick, ME (& travelling)

Woodforms, Brockton Art Museum (Fuller Memorial), Brockton, MA

A Haystack Celebration, Aaron Faber Gallery, New York, NY

Sculpture/New Hampshire, Phenix Gallery, New Hampshire Commission on the Arts, Concord, NH

1982 *New Hampshire Painters and Sculptors,* Plymouth State College, Plymouth, NH

Wood and Fiber, The Columbia Museum of Art, Columbia, SC

Mark and Melvin Lindquist, Columbus Museum of Art, Columbus, OH

Glass, Clay, Wood, Galerie Ninety-Nine and Medici-Berenson Gallery, Bay Harbor Islands, FL

Melvin and Mark Lindquist, HumanArts Gallery, Dallas, TX

Mark and Melvin Lindquist: Recent Work, The Works Gallery, Philadelphia, PA

1983 *The Art of Wood Turning,* American Craft Museum, New York, NY

Masterworks, Jesse Besser Museum, Alpena, MI

Masterworks, Habatat Gallery, Lathrup Village, MI

Turned Wood Object, The Hand and the Spirit Gallery, Scottsdale, AZ

1984 *New Discoveries of Ancient Realms: Melvin and Mark Lindquist,* HumanArts Gallery, Dallas, TX

Venture Gallery (Habatat Galleries), Lathrup Village, MI

1985 *The Edward Jacobson Collection of American Turned Wood Bowls,* Arizona State University, Tempe, AZ (& travelling)

Woodturning: Vision and Concept, Arrowmont School of Arts and Crafts, Gatlinburg, TN

1986 *Craft Today: Poetry of the Physical,* American Craft Museum, New York, NY
 New Works 1986, Brockton Art Museum (Fuller Memorial), Brockton, MA
 Ob'Art, Les Ateliers d'Art, Paris, France
 The Art Form of Woodturning, The Hand and the Spirit Gallery, Scottsdale, AZ
 Chicago International Art Exposition (G. H. Dalsheimer Gallery)
 Susan Cummins Gallery, Mill Valley, CA

1987 *Artistry in Wood,* High Museum of Art, Atlanta, GA
 Works Off the Lathe: Old and New Faces, Craft Alliance Gallery, St. Louis, MO

1988 *International Turned Objects Show,* Port of History Museum, Philadelphia, PA (& travelling)
 Bennett Bean, Lynn Last, Mark Lindquist, Marvin Lipofsky, Judy Kensley McKie, Janet Prip,
 John Prip, Gimpel Weitzenhoffer Gallery, New York, NY

1989 Wilson & Gough Gallery, London, England
 The Grand Masters of Woodturning, Franklin Parrasch Gallery, Washington, DC
 Image Gallery, Sarasota, FL

1990 *NEA Artists,* Florida State University, Tallahassee, FL
 Ann Jaffe Gallery, Bay Harbor Islands, FL
 Contemporary Masters: Current Work by Artists of The Jacobson Collection, del Mano Gallery,
 Los Angeles, CA

1991 *Collecting American Decorative Arts and Sculpture,* Museum of Fine Arts, Boston, MA
 Florida Craftsmen: 40th Anniversary Exhibition, Tampa Museum of Art, Tampa, FL
 (& travelling)
 Southern Arts Federation NEA Grant Recipients, Southern Arts Federation, Atlanta, GA

1992 *American Crafts: The Nation's Collection,* Renwick Gallery, Smithsonian Institution
 Out of the Woods—Turned Wood by American Craftsmen, Fine Arts Museum of the South,
 Mobile, AL (& travelling)
 Spiritual Concerns in Contemporary Art, Northern Michigan University, Marquette, MI
 Master Turners, del Mano Gallery, Los Angeles, CA

1993 *The Art of the Woodturner,* High Museum of Art, Atlanta, GA
 Contemporary Crafts and the Saxe Collection, The Toledo Museum of Art, Toledo, OH
 Crafts at the White House, The White House, Washington, DC
 Turned Wood by American Craftsmen, Fine Arts Museum of the South, Mobile, AL
 (& European tour)

National Objects Invitational, The Arkansas Arts Center Decorative Arts Museum,
Little Rock, AR
Master Woodturners, Mendelson Gallery, Washington Depot, CT

1994 *Eight Contemporary Sculptors—Beyond Nature: Wood Into Art,* Lowe Art Museum, University
of Miami, Miami, FL
The Label Show: Contemporary Art and the Museum, Museum of Fine Arts, Boston, MA
Treasures in Our Midst, Fuller Museum of Art, Brockton, MA
Turned Wood '94: 11th Annual Exhibition of Lathe Turned Objects, del Mano Gallery,
Los Angeles, CA

1995 *Fine Crafts Biennial Invitational,* Florida Gulf Coast Art Center, Belleair, FL
The White House Collection of American Crafts, National Museum of American Art,
Washington, DC (& travelling)

Public Collections

The American Craft Museum, New York, NY

Arrowmont School of Arts and Crafts, Gatlinburg, TN

Arizona State University, Tempe, AZ

Dallas Museum of Art, Dallas, TX

Ethan Allen Inc., Danbury, CT

Fine Arts Museum of the South, Mobile, AL

Fuller Museum of Art, Brockton, MA

Greenville County Museum of Art, Greenville, SC

High Museum of Art, Atlanta, GA

The Metropolitan Museum of Art, New York, NY

Museum of Fine Arts, Boston, MA

Nations Bank Corporate Headquarters, Charlotte, NC

The Quincy State Bank, Quincy, FL

Renwick Gallery, National Museum of American Art, Washington, DC

Philadelphia Museum of Art, Philadelphia, PA

The Schenectady Museum, Schenectady, NY

Virginia Museum of Fine Arts, Richmond, VA

The White House, Washington, DC

The Woodturning Center, Philadelphia, PA

Selected Bibliography

Books and Exhibition Catalogues

American Craft Museum. *The Art of Wood Turning*. Introduction by Paul J. Smith; essay by Christopher Wilk. New York, 1983.

American Craft Museum. *Craft Today, Poetry of the Physical*. Text by Paul J. Smith and Edward Lucie-Smith. New York, 1986.

American Craft Museum. *For the Tabletop*. New York, 1980.

American Craft Museum. *New Handmade Furniture: American Furniture Makers Working in Hardwood*. Introduction by Paul J. Smith. New York, 1979.

Bevlin, Marjorie Elliott. *Design Through Discovery*. New York: Holt, Rinehart and Winston, 1977.

Brevard Art Center and Museum. *Mark Lindquist: Turned Wood Sculptures*. Melbourne, FL, 1986.

Brockton Art Museum/Fuller Memorial. *Woodforms*. Introduction by John Heller. Brockton, MA, 1981.

Columbia Museum of Art. *Wood and Fiber*. Columbia, SC, 1982.

Craft Alliance Gallery. *Works off the Lathe: Old and New Faces*. St. Louis, MO, 1987.

Craft Center. *American Woodcarvers*. Worcester, MA, 1978.

De Cordova Museum. *Bed and Board*. Lincoln, MA, 1975.

Faulkner, Ray, and Edwin Ziegfeld, and Howard Smagula. *Art Today: An Introduction to the Visual Arts*. 6th ed. New York: Holt, Rinehart and Winston, 1987

Fine Arts Museum of the South. *Out of the Woods: Turned Wood by American Craftsmen*. Essay by Dale Nish. Mobile, AL, 1992.

Greenville County Museum of Art. *Mark Lindquist: Works in Wood*. Greenville, SC, 1979.

Herbert F. Johnson Museum of Art, Cornell University. *The Handwrought Object, 1776-1976*. Ithaca, NY, 1976.

Jacobson, Edward. *The Art of Turned Wood Bowls*. New York: E. P. Dutton, 1985.

Lindquist, Mark. *A Selection of Works: 1975-1980*. Henniker, NH: Lindquist Studios, 1981.

Lindquist, Mark. *Sculpting Wood*. Worcester, MA: Davis Publications, 1986.

Lowe Art Museum, University of Miami. *Eight Contemporary Sculptors*. Essay by Josephine Gear. Miami, FL, 1994.

Mayer, Barbara. *Contemporary American Craft Art, A Collector's Guide*. Salt Lake City: Gibbs M. Smith, Inc., 1987.

Meilach, Dona Z. *Creating Small Wood Objects as Functional Sculpture*. New York: Crown Publishers, 1976.

Museum of Contemporary Crafts of the American Crafts Council. *Young Americans: Fiber, Wood, Plastic, Leather*. New York, NY, 1977.

Museum of Fine Arts, Boston. *Collecting American Decorative Arts and Sculpture*. Introduction by Jonathan L. Fairbanks, text by Edward S. Cooke, Jr., Jeannine J. Falino and others. 1991.

Nish, Dale L. *Artistic Woodturning*. Provo: B.Y.U. Press, 1980.

Nish, Dale L. *Master Woodturners*. Provo: Artisan Press, 1985.

Franklin Parrasch Gallery. *Mark Lindquist: Stratigraphs and De-Compositions*. Essay by Robert
 Hobbs. New York, 1990.

Pearson, Catherine. *Decorating with Crafts*. New York: Stewart, Tabori and Chang, 1984.

Schachtman, Tom. *The President Builds a House*. Introduction by Jimmy Carter. New York:
 Simon and Schuster, 1989.

Tampa Museum of Art. *Florida Craftsmen, 40th Anniversary Exhibition*. Introduction by
 R. Andrew Maass. 1991.

Toledo Museum of Art. *Contemporary Crafts and the Saxe Collection*. Essays by Davira S.
 Taragin, Jane Fassett Brite, Edward S. Cooke, Jr., Helen W. Drutt English, and others. 1993.

The White House. *The White House Collection of American Crafts*. Opening statement by
 Hillary Rodham Clinton; text by Michael Monroe; essay by Barbaralee Diamonstein.
 New York: Harry N. Abrams, Inc., 1995.

Wood Turning Center. *Lathe-Turned Objects: An International Exhibition*. Curated by
 Albert LeCoff. Philadelphia, PA, 1988.

Newspaper and Magazine Articles

"American Woodturners' Seminar." *Practical Woodworking* (England) (March 1986), pp. 61-62.

"Acquisitions." *American Craft* 54:5 (October/November 1994), p. 44.

Barnes, Roger. "American Woodcarvers: Exhibit blurs traditional definitions."
 Fine Woodworking 11 (Summer 1978), pp. 47-49.

"Beyond the Bowl." *Fine Woodworking* 32 (January/February 1982), p. 108.

"Celebrating Masterly Wood Turning." *The New York Times,* April 20, 1989, p. C3.

Chambers, Karen. "Exhibitions: New York." *Craft International* (April 1983), p. 42.

"Crafted Environments: The Southern Arts Federation/National Endowment for the Arts
 Awards in Crafts." *American Craft* 52:1 (February/March 1992), insert @ p. 64.

"Crafts at the White House." *American Craft* 54:3 (June/July 1994), pp. 50-53.

Cropper, Carol M. "Turned On by Turned Wood." *Forbes* (September 14, 1992), pp. 508-510.

Crosson, Dena. "Bowled Over." *Washington Home and Garden* (Fall 1991), pp. 25-26.

Detjen, Jim. "Living with Crafts Exhibit at Rhinebeck Fair." *Poughkeepsie Journal,*
 August 22, 1974.

Edgar, Natalie. "Sixteen American Woodcarvers." *Craft Horizons* XXXVIII:2 (April 1978),
 pp. 36-37.

Ehrmann, Siegfried. "Gedrechseltes - made in U.S.A." *Holz und Elfenbein* (Germany) 1/84
 (January/February), pp. 4-6.

Ehrmann, Siegfried. "Gedrechseltes - made in U.S.A., Portrat: Melvin und Mark Lindquist." *Holz und Elfenbein* (Germany) 2/84 (Mars/April), pp. 28-31.

"Exhibitions: New York/Sculpture and Craft." *Craft Horizons* XXXVI:4 (August 1976), p. 50.

"Exhibitions/Wood: Mark Lindquist." *American Craft* 39:4 (August/September 1979), p. 58.

Fox, Catherine. "The Lindquists Change Fallen Trees into Bowls." *The Atlanta Journal/The Atlanta Constitution*, December 26, 1982, p. 3-G.

"Gallery/Wood: Mark Lindquist." *American Craft* 46:3 (June/July 1986), p. 81.

"Gallery/Wood: Melvin and Mark Lindquist." *American Craft* 42:5 (October/November 1982), p. 69.

Geneslaw, Ruth. "Mark Lindquist—Wayne Raab." *Craft Horizons* XXXVI:2 (April 1976), p. 62.

Hammel, Lisa. "Shaping the Beauty of Wood Into Abstractions and Realities." *The New York Times,* May 20, 1976.

Hammel, Lisa. "Wood Sculptors Feud Often, But It's All in the Family." *The New York Times,* November 19, 1975.

Hansson, Bobby. "World Turnout." *American Craft* 53:4 (August/September 1993), pp. 20-23.

Hobbs, Robert. "Review: Mark Lindquist at Franklin Parrasch Gallery, New York." *Sculpture* 9:2 (March/April 1990), pp. 55-56.

Howe, Robert. "Creating and Living With Finely Turned Crafts." *The Washington Post/Washington Home,* April 25, 1985, pp. 20-22.

Huxtable, Ada Louise. "Design Notebook." *The New York Times,* October 9, 1980, p. C10.

Jepson, Barbara. "As the Wood Turns: From Logs Into Art." *Wall Street Journal,* December 27, 1983.

Kelsey, John. "The Turned Bowl." *Fine Woodworking* 32 (January/February 1982), pp. 54-60.

Kersgaard, Scot. "Unleashing Wood Sculptures on the World." *Wood River (ID) Journal,* August 12, 1987, p. 14B.

Key, Ray. "Superbowl." *Crafts* (England) 78 (January/February 1986), pp. 28-31.

Koncius, Jura. "Masters of Turned Wood." *The Washington Post/Washington Home,* April 13, 1989, pp. 30, 32.

Kohen, Helen L. "Artists Carve Trees Into Powerful Sculpture." *The Herald (Miami),* May 8, 1994, p. 61.

Kostof, Spiro. "Comment" (Keynote Address at the American Craft Council National Conference, 1986). *American Craft* 48:3 (June/July 1988), pp. 16-17, 90-93.

"Lathe-Turned." *American Craft* 46:1 (February/March 1986), pp. 36-39.

Lindquist, Mark. "Ascending Bowl." *The Studio Potter* 10:2 (June 1982), pp. 40-41.

Lindquist, Mark. "Ascending Bowl." *Kunsthandverk* (Norway) (9/10 1983), pp. 12-13.

Lindquist, Mark. "Harvesting Burls." *Fine Woodworking* 47 (July/August 1984), pp. 67-71.

Lindquist, Mark. "Letters: Ascending Bowl." *The Studio Potter* 11:1 (December 1982).

Lindquist, Mark. "Spalted Wood." *Fine Woodworking* 2:1 (Summer 1977), pp. 50-53.

Lindquist, Mark. "Turning Spalted Wood." *Fine Woodworking* 11 (Summer 1978), pp. 54-59.

"Lindquist Woodcrafts at City Museum." *The Schenectady Gazette,* July 15, 1975.

Malarcher, Patricia. "Crafts: Ten Years in the Life of a Gallery." *The New York Times,* April 10, 1983.

"Mark and Melvin Lindquist at The Works." *Art Now/Philadelphia Gallery Guide* 2:9 (May 1982), pp. 1-2.

Miro, Marsha. "Modern Masters of Glass and Wood." *Detroit Free Press,* February 19, 1984, p. 8G.

Nigrosh, Leon and Dick Sauer. "Exhibitions: Massachusetts." *Craft Horizons* (October 1975).

Nutt, Craig. "Woodturners Gather at Arrowmont." *American Craft* 46:1 (February/March 1986), p. 95.

O'Donnell, Michael. "Exhibitions: Woodturning—Vision and Concept." *Craftwork* (Scotland) 11 (Spring 1986), p. 28.

Palladino-Craig, Allys. "Mark Lindquist: Making Split Decisions." *Art Today* 4:1 (Spring 1989), pp. 24-28, 48.

Perreault, John. "Turning Point." *American Craft* 49:1 (February/March 1989), pp. 24-31 & front cover.

Reif, Rita. "The Crafts of America Find Recognition at the Top." *The New York Times,* December 23, 1993, pp. B1, B4.

Robinson, Ruth. "Art in Metal and Wood." *The New York Times,* December 18, 1976.

Rosand, Robert. "*Sculpting Wood: Contemporary Tools and Techniques* by Mark Lindquist." *American Woodturner* 10:2 (June 1995), p. 38.

Rubenfeld, Florence. "Turn, Turn, Turn." *Museum and Arts Washington* V:2 (March/April 1989), pp. 38-40.

"Shops and Galleries." *American Craft* 50:1 (February/March 1990), p. 24.

Siegel, Roslyn. "Sculptors Search for the Perfect Log." *The New York Times,* May 3, 1979, p. C7.

Smith, Virginia Warren. "The Offbeat Takes Beautiful Shape." *The Atlanta Journal/The Atlanta Constitution,* June 26, 1991, p. B6.

Sporkin, Elizabeth. "Crafts Move Into Art World." *USA Today,* February 8, 1983, p. 3D.

Welzenbach, Michael. "Galleries: Masters of Woodturning at Franklin Parrasch." *The Washington Post,* May 13, 1989, p. C2.

Whitley, Robert. "Melvin and Mark Lindquist at The Works Craft Gallery." *Arts Exchange* (Philadelphia) 2:4 (July/August 1978), pp. 14-15.

"Wood, Clay, and Glass." *New York Magazine* (September 17, 1979), p. 49.

Wright, Nancy Means. "Mark Lindquist: The Bowl is a Performance." *American Craft,* 40:5 (October/November 1980), pp. 22-27.

Catalogue of the Exhibition

All dimensions are in inches: height precedes width.

1969-70 *Early Spalted Bowl,* spalted maple, 3½ x 5½, collection of the artist

1970 *Turned Spalted Bowl with Bark Inclusion,* spalted maple burl, 5 x 11, collection of the artist

1971 *Go Paul-Go,* turned and carved vase, butternut, 9 x 5, collection of the artist
Fluted Bowl, turned and carved, butternut, 5½ x 6, collection of the artist

1972 *Natural Top Bowl,* maple burl, 2½ x 5¾, collection of the artist
Meditating Vessel, white birch root burl, 4 x 7¼, collection of the artist

1973 *Turned Bowl,* spalted yellow birch, 5½ x 10, collection of Kathleen Lindquist

1975 *Natural Fault Covered Jar,* cherry burl, 3¼ x 2¾, collection of Joshua Lindquist
Turned and Carved Jar with Sphere Nesting on Top, cherry burl, 5¼ x 4, collection of Benjamin Lindquist
Turned and Carved Sculptural Bowl with Carved Spoon, spalted maple, 6¼ x 8½, collection of Greenville County Museum of Art, Greenville, SC, museum purchase with assistance from the National Endowment for the Arts
The Great American Chestnut Burl Bowl, chestnut burl, 5 x 14, collection of Joan Alpert Rowen, CA

1976 *Lock Top Covered Jar,* spalted tiger maple, 3½ x 4, private collection
Turned and Carved Covered Jar with Sculptural Handle, elm burl, 8 x 5½, private collection
Lazarus Vessel, homemade spalted maple, 3¼ x 8¾, collection of the artist

1977 *Turned and Carved Footed Sculptural Vessel,* maple burl, 5 x 10, collection of Arthur and Jane Mason

1979 *Sculptural Vessel,* white ash burl, 24 x 20 x 26, collection of Ronald and Anita Wornick
Rolling Thunder, maple burl, 14 x 32, collection of Gary and Ruth Sams
First-Fruit Bowl, spalted maple, 7¼ x 14, private collection

1980 *Amiran Krater,* mahogany, 12 x 11, collection of Robert A. Roth

1981 *The MacDowell Bowl,* spalted elm, 23 x 33, collection of Dr. and Mrs. Alan R. Lubarr
Spalted Elm Burl Natural Top Bowl, spalted elm burl, 16 x 12, Arrowmont School of Arts and Crafts permanent collection